BISHOP'S STORTFORD, BRAINTREE, WITHAM & MALDON RAILWAYS

THROUGH TIME
Andy T. Wallis

AMBERLEY PUBLISHING

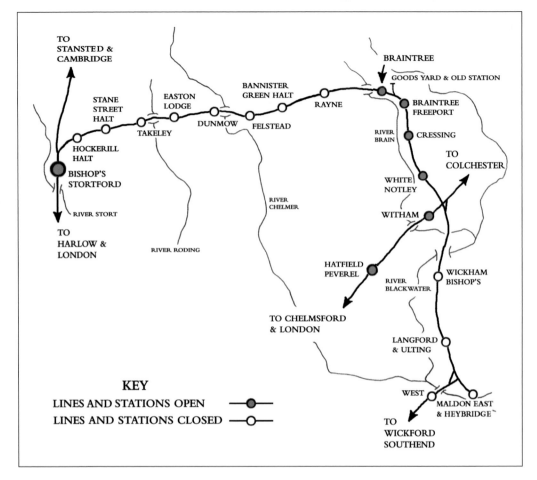

To big and little sister for the encouragement, and for keeping me focused on the project.

First published 2013

Amberley Publishing
The Hill, Stroud
Gloucestershire, GL5 4EP

www.amberley-books.com

Copyright © Andy T. Wallis, 2013

The right of Andy T. Wallis to be identified as the
Author of this work has been asserted in accordance
with the Copyrights, Designs and Patents Act 1988.

ISBN 978 1 4456 0856 3

British Library Cataloguing in Publication Data.
A catalogue record for this book is available from
the British Library.

Typeset in 9.5pt on 12pt Celeste.
Typesetting by Amberley Publishing.
Printed in the UK.

Introduction

The railway first arrived at Witham in March 1843 courtesy of the Eastern Counties Railway. The Braintree and Maldon branches received parliamentary sanction on 18 June 1846 as the Maldon, Witham & Braintree Railway Company, but a short time later the ECR took over the independent company's assets, and construction started in 1847. The new double-tracked lines opened in 1848, and from the outset the ECR operated them as two separate branches. The double track on both branches only lasted a short time, and the second tracks were lifted and reused elsewhere in around 1850.

The Bishop's Stortford, Dunmow & Braintree Railway was first planned in 1860 as an independent company to link the three towns. Raising the necessary capital was proving very difficult until the new Great Eastern Railway obtained powers to lease or purchase the proposed railway. A new contractor allowed work to commence in early 1864, and the line eventually opened in 1869 after the third attempt to get the works approved by the Board of Trade Inspector. A new station was provided at Braintree, and is still open today; the old station became part of the goods yard.

Under the Great Eastern Railway (GER) all three lines started to develop nicely with improved passenger and freight revenues, and by the eve of the First World War there were six trains a day between Bishop's Stortford and Braintree, nine or ten between Braintree and Witham, and eight between Witham and Maldon. In 1890 a new halt was opened at Easton Lodge to enable the Prince of Wales to visit Lady Brooke. In 1910 a further halt was opened at Hockerill to serve the nearby golf course. On the Maldon branch a new line was opened from Woodham Ferrers, together with new junctions at Maldon and Witham, to allow through-running from Southend to Colchester. These junctions were short-lived and were removed after the through trains ceased running.

Maldon station was renamed Maldon East on 1 October 1889. When Maldon West station opened later, in 1907, the suffix 'and Heybridge' was added.

A further two halts were opened at Bannister Green and Stane Street in 1922, the final improvement from the GER, as on 1 January 1923 the old GER became part of the London & North Eastern Railway (LNER).

Improvements in signalling followed in the LNER days, with the old Train Staff and Ticket system being replaced by Electric Token working between Witham and Bishop's Stortford by 1931. New goods loops were also provided at Felsted and Takeley to assist with the flow of traffic over the Dunmow line. The Maldon line retained its Train Staff and Ticket working until the end of the passenger service.

The Second World War brought heavy traffic to all the lines. The sparse passenger service from Maldon East to Woodham Ferrers was suspended

at the beginning of the war, never to be resumed. After the war passenger services returned to the pre-war levels on both the Braintree and Maldon lines; however the passenger service between Bishop's Stortford and Braintree was losing customers to the rival bus company, and it was proposed by the British Transport Commission to withdraw the passenger service, which duly went ahead. The last train ran on 1 March 1952, but the line was kept open for freight traffic, and for special excursions and other diversions.

Diesel railcars were introduced on the Maldon line from 1956, replacing the steam-hauled passenger services. Seventeen trips a day were provided between Witham and Maldon. In 1958 smaller diesel railbuses were introduced on both the Maldon and Braintree lines to help reduce costs. After publication of the Beeching Report in 1963, both branches were marked down to close. However a campaign had been launched to save the service on the Braintree line, and by publicising the service the decline in passenger usage was reversed, and the train service was improved, with the diesel railbus being replaced by a two-car DMU. The threat of closure was lifted in 1966, provided growth continued, which it did.

Despite large cost savings by using railbuses the Maldon line was still losing money, and the passenger service was withdrawn from 7 September 1964, although the line remained open for freight. The freight service lasted until 18 April 1966, when Maldon East depot closed completely, together with the freight depots at Witham and Braintree. On the Dunmow line freight revenues benefited from a contract to move bananas to a new ripening depot at Easton Lodge in 1962. Goods services were withdrawn from Rayne and Felsted stations in 1964, but this did not include sugar beet traffic. Takeley followed in January 1966, and this just left coal traffic, which survived for a few more months.

The Dunmow line became two separate branches after engineers declared the viaduct near Dunmow unsafe in early 1966, the section between Dunmow and Felsted closing completely from April 1966. As traffic declined on the Braintree to Felsted part of the line this too was closed from 1 April 1969. Track lifting took place here in 1970, and included the second platform line at Braintree; track lifting on the Maldon branch took place in 1969. On the Bishop's Stortford to Dunmow part of the line, Dunmow station also closed in April 1969, which just left the banana traffic to Easton Lodge, which ceased to be carried by rail in 1971. A special train visited the remains of the branch in July 1972, and track lifting followed shortly afterwards.

Growth of the passenger service on the Braintree line continued until electrification was authorised in 1976, and completed in 1977, with the first electric trains running from 31 October. The service was a success from the outset, with daily through services to London Liverpool Street.

ATW

March 2013

Bishop's Stortford

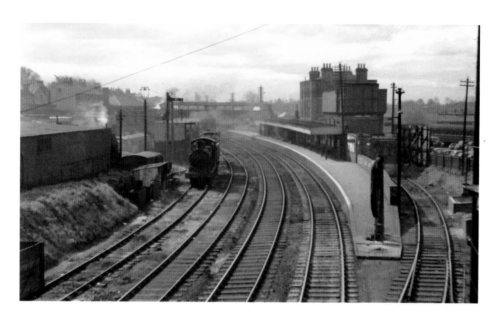

View from Hockerill overbridge looking south towards the station, taken on 28 April 1956. The lines from left to right are the loco siding, the Dunmow single line, Up main line and Down main line. At this time there was a short siding behind the Down platform. Note the water crane at the Cambridge end of the Down main platform. (Brian Connell/Photos from the Fifties)

Unable to replicate the above picture, this view is from the Down platform looking north towards Cambridge, with the former Dunmow branch adjacent on the right and, beyond, the buffer stops. For many years a much longer portion of the branch was retained, together with some of the point work. (Andy T. Wallis)

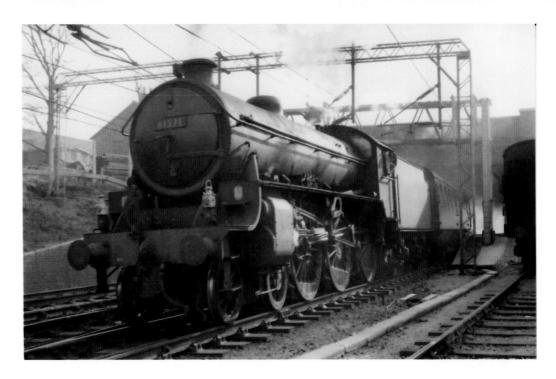

Two contrasting views taken in November 1960, just prior to the commissioning of the electrification scheme. Travelling northwards towards Cambridge is Class B1 locomotive 61271, with a main line service to Cambridge standing at the end of the Down platform. On the same day the next generation of diesel is seen on a Cambridge service, with Brush Type 2 locomotive D5528 in charge, later designated Class 31s. Note the water crane has now gone and has been replaced with an overhead line stanchion. (Railway Correspondence and Travel Society Archive)

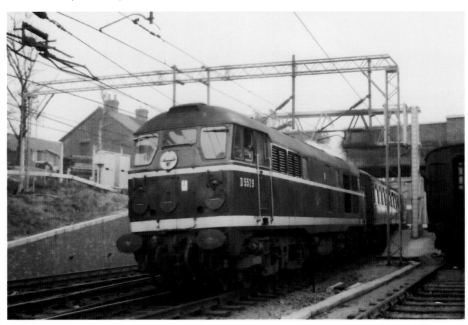

A view taken of the 10.51 train from Braintree, approaching the main line near to Bishop's Stortford, on 26 February 1952, just a few days before the branch passenger service was withdrawn. The bridge in the foreground is a footbridge crossing over the Cambridge main line. (R. E. Vincent/Transport Treasury)

Today most of the former trackbed within the town boundaries has been sold off. This view of the former line now forms part of an extended garden, before merging with the main line on the right. (Andy T. Wallis)

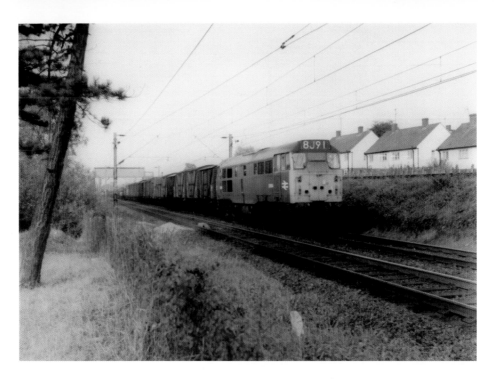

D5554 hauling a Class 8 freight service, approaching Bishop's Stortford in 1970. The bridge mentioned in the previous picture can be seen in the background. The Dunmow line would have climbed the bank behind the locomotive; the former line had a gradient of 1 in 66, before turning sharply to the right on a 15-chain curve around the top of the town. (Brian Barham)

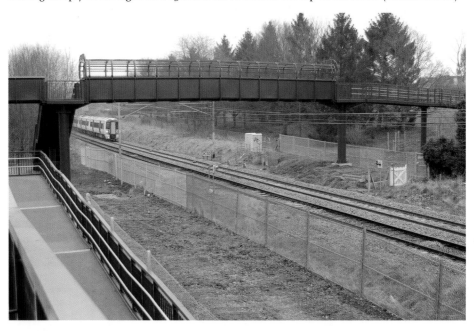

Taking advantage of a recently installed footbridge, a Stansted Airport service is seen travelling south towards London. (Andy T. Wallis)

Hockerill Halt

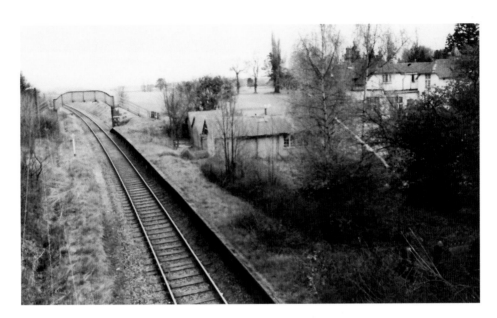

A 1962 view of the platform at Hockerill Halt. The last passenger train had called here in 1952. The halt was located 1 mile 29 chains from Bishop's Stortford, and consisted of a single, 200-foot-high platform on the Up side of the line. Originally provided for the use of golfers at the nearby golf club, it had been opened on 7 November 1910 by the Great Eastern Railway. (Stations UK)

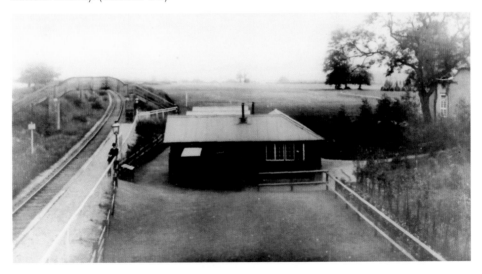

The opening photograph, taken around 1910, of the new halt, which was originally for use by people visiting the golf club. There were two entrances to the platform, the first by the overbridge at the Dunmow end of the platform, and the other via a step of steps from the main road overbridge. (Lens of Sutton Collection)

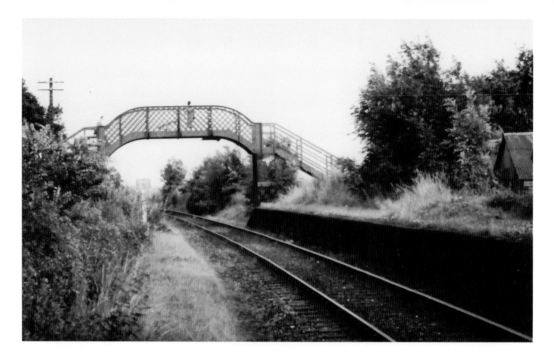

Close-up view of Hockerill Halt showing the footbridge over the line, originally provided for golfers to access the greens on either side of the track. When the halt originally opened in 1910 access was from a footpath from the back of the platform to the clubhouse. When the general public started to use the halt a step of steps was provided from the road overbridge. (Rail Archive Stephenson)

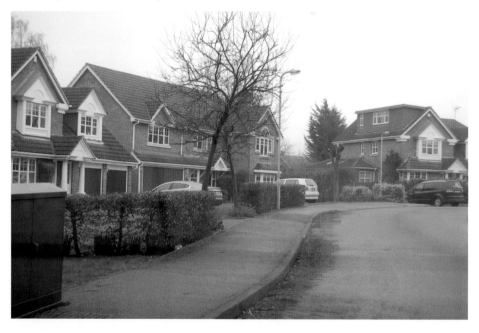

Today the halt, and part of the golf course and trackbed, have been swept away to form a small new housing development. (Andy T. Wallis)

View from the disused platform, looking back at the road overbridge, towards Bishop's Stortford. Access used to be from the bridge down some steps on the left-hand side. The points under the bridge led to the former governmental cold storage depot, opened at the beginning of the war, with the siding connection being provided in 1942. The points were operated by a ground frame, with an Annett's key being attached to the electric train staff for the Bishop's Stortford to Takeley section. (Chris Gammell/Photos from the Fifties)

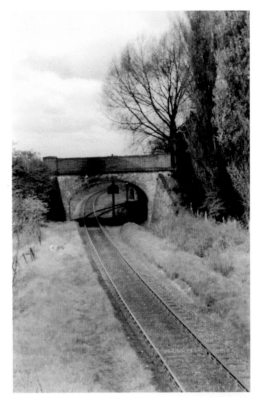

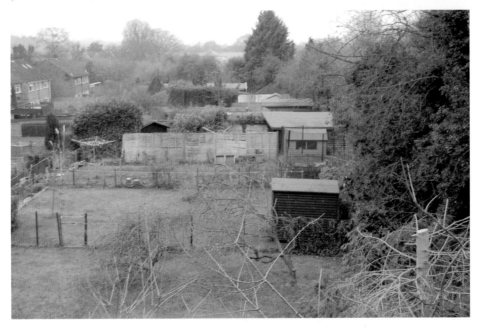

Unable to re-create the same view, due to houses being built on the former railway land, this view is taken from Stortford Hall Park bridge looking west, and shows all the former railway land. It has now been taken over by garden extensions, and it is hard to believe that a railway once ran through here. (Andy T. Wallis)

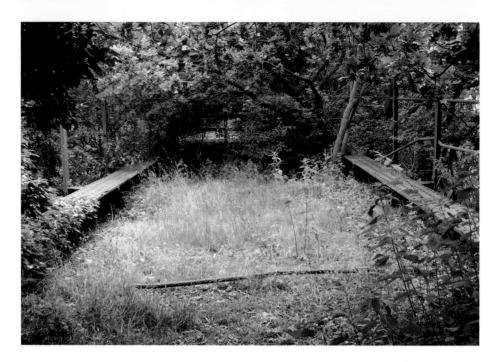

Two views taken in 2013 of the end of the former railway at Lewis underbridge, No. 2071, located 2 miles 27 chains from Bishop's Stortford, which was an occupation bridge for the local landowner. It also spanned a very small stream. Beyond the wooden fence the trackbed has been cut away to accommodate the M11, built in the 1970s. The view below shows the original steel girders supported by brick abutments; the span was just over 23 feet. Some 15 miles of the old railway now form part of the Flitch Way. (James Messer)

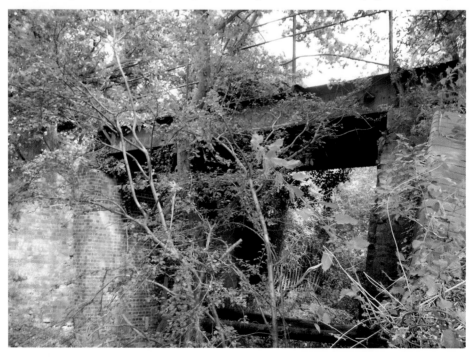

Stane Street Halt

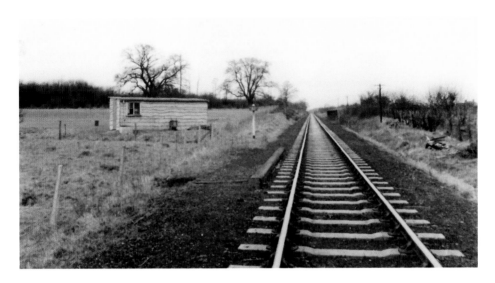

The remains of the halt, seen in 1955, which was provided by the Great Eastern Railway on 18 December 1922 and consisted of a 30-foot-long clinker-filled platform with a timber face up to rail level. There was also a name board, and an oil lamp mounted on a post to provide illumination. This view is looking towards Bishop's Stortford. Access was from a footpath that led down to the adjacent side road. (Stations UK)

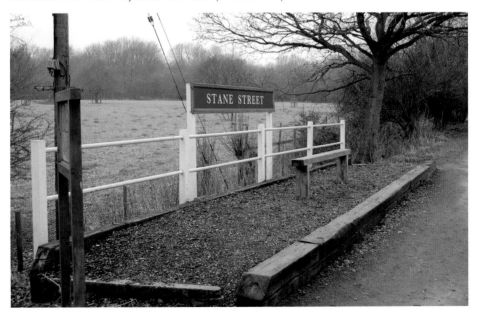

Replica of the halt, erected by 'Friends of the Flitch Way and Associated Woodlands'. The former trackbed of the railway is now designated the 'Flitch Way', and volunteers help to keep it in good order. This view is looking towards Bishop's Stortford. (Andy T. Wallis)

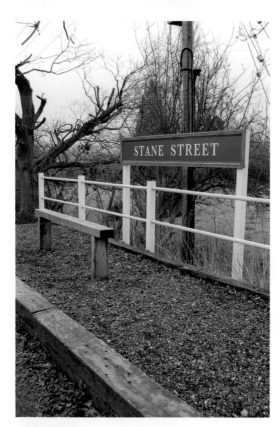

Close-up view of the Stane Street Halt. Rebuilt in the same location as the previous, and provided for users of the 'Flitch Way' path and cycleway, it is built on the former railway trackbed. (Andy T. Wallis)

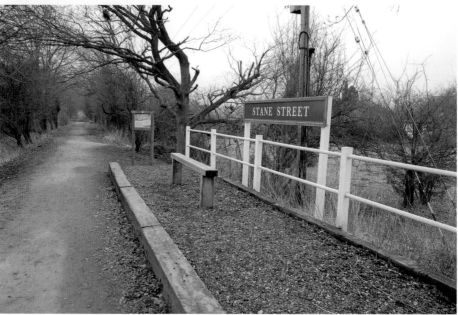

A view along the old railway looking east towards Takeley. The gradient at this point was falling. Just beyond the sign there is an access point that takes you down to the main road that links Takeley with Hatfield Forest. (Andy T. Wallis)

Takeley

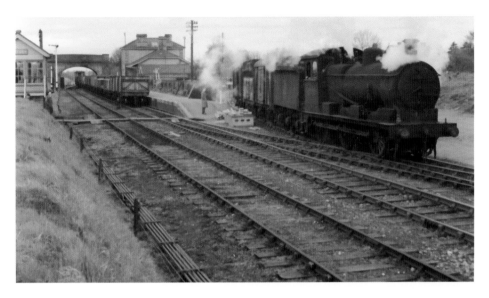

Takeley station with a J17 locomotive shunting the small goods yard. Part of the train has been left standing on the main single line. The line on the left was the old goods loop, which was out of use by this time. Note the tall lower quadrant signal adjacent to the road overbridge. (Brian Connell/Photos from the Fifties)

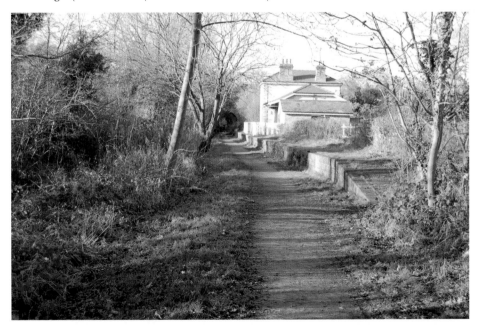

Today the station has been tastefully restored, with the platform intact. The trackbed is now part of the Flitch Way, available to walkers, cyclists and horse riders. (James Messer)

Close-up view of the tranships shed at Takeley, seen in February 1952 from the carriage window of a passenger train standing in the platform. (R. E. Vincent/ Transport Treasury)

Today the doors have been replaced with a window as part of the improvements to the station. The original curved brickwork that used to be over the doorway can still be clearly seen. (James Messer)

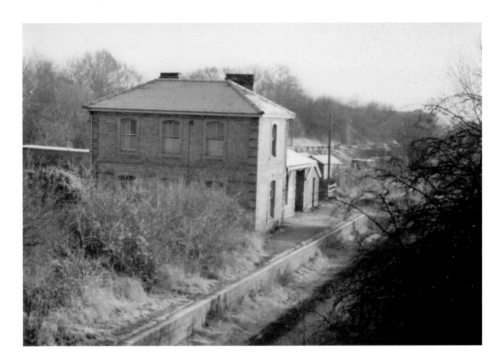

On a frosty Sunday morning in early 1980 this was the view from the overbridge adjacent to the station. At this time the station was still owned by the railway, and a tenant still lived in the station house. The trackbed was used as an unofficial footpath at this time. (Andy T. Wallis)

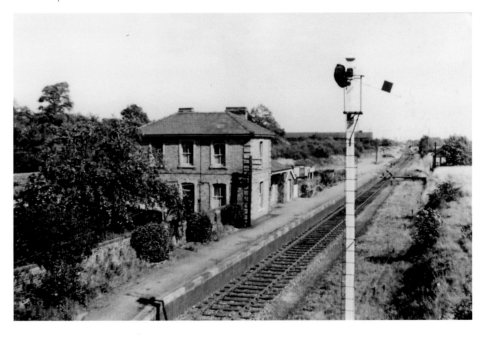

Some eighteen years earlier the railway was still open to freight and excursion traffic. The goods loop had been removed many years earlier, and the signal box now only acted as a ground frame when a train needed to shunt the yard. (R. M. Casserley)

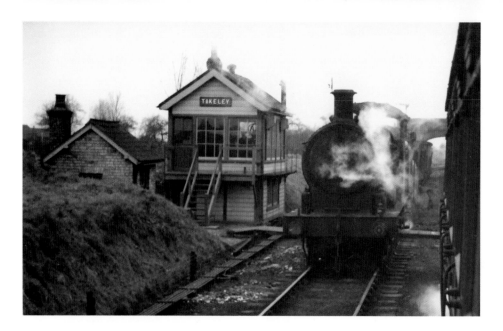

A view of a Down freight, hauled by a Class J19 locomotive, standing in the goods loop at Takeley, taken from a carriage window on 26 February 1952. The signal box and lamp room were built into a slight recess in the embankment. The signal box was fitted with a twenty-six-lever frame from 1926 when the goods loop was added to the layout. The section between Bishop's Stortford North signal box and Takeley was operated by a large electric train staff, as was the section onwards to Dunmow. (R. E. Vincent/Transport Treasury)

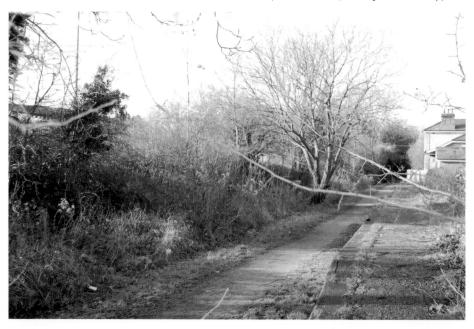

A similar view, this time taken from the end of the platform in December 2012, shows the trackbed clear of obstructions. Vegetation and trees have taken over the former site of the goods loop and signal box. The signal box was actually sited on the left in this view. (James Messer)

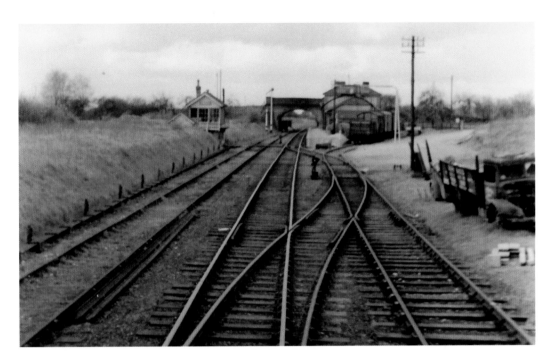

Standing in the small yard, looking back towards Bishop's Stortford, showing the complete track layout before the goods loop was removed. Some freight wagons can be seen standing in the siding behind the platform. Unusually there were three connections from the main single line to the goods yard. Two can be seen in this view; the third was behind the photographer. (Chris Gammell/Photos from the Fifties)

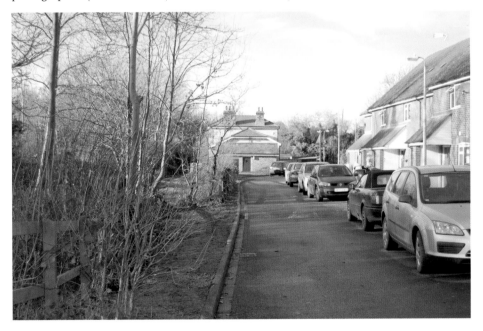

Today the goods yard has houses built on it, with an access road now covering the siding shown on the right in the top view. (James Messer)

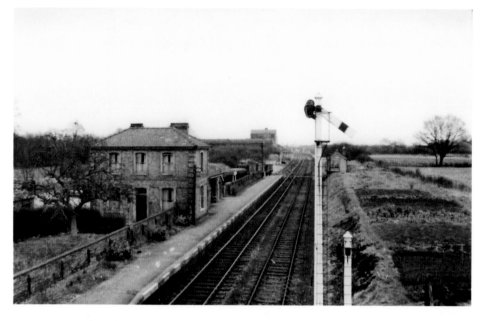

A 1955 view, taken from the road overbridge, looking towards Dunmow. At this time the goods loop was out of use pending the lifting of the track. The short signal on the right has been shorn of its semaphore arm. Takeley ceased to be a block post from 1958, when the signal box was downgraded to a ground frame. The signals were left in the off position. At this time the station still looked very neat and tidy. (Stations UK)

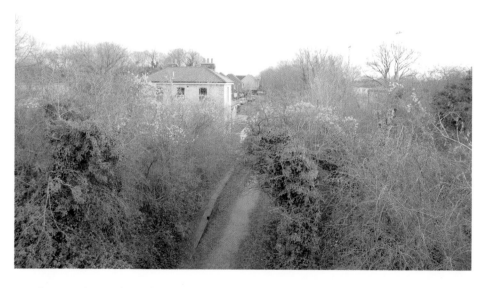

Standing on the road overbridge today, the station is nearly completely hidden by trees and shrubs which have grown in the intervening years. This view was taken in December 2012. (James Messer)

Easton Lodge Halt

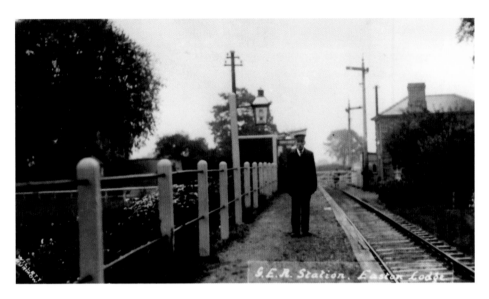

Very early GER view of the halt. The gentleman in the picture, whose name was Charles Green, was the foreman-in-charge of the station at that time. He served at Easton Lodge from 1899 to 1911, making this picture over a hundred years old. (Lens of Sutton Collection)

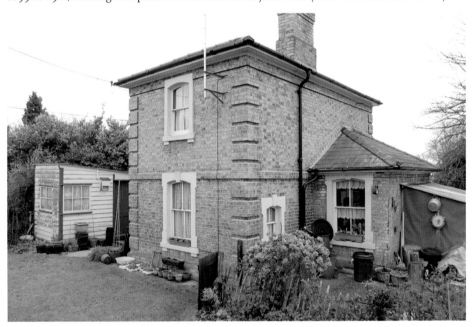

Standing in the garden, with permission, we see the crossing house and the old ground frame hut, which contained a five-lever frame to control the signals and gate-locking equipment. This view was taken in December 2012. (James Messer)

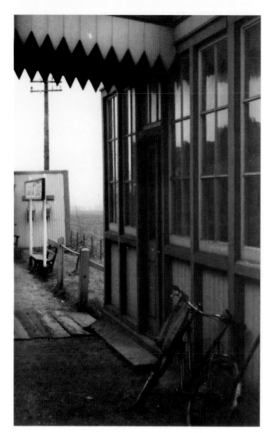

A view from a passing train of the small, wooden station building at the halt. The platform was on the Down or north side of the line immediately beyond the level crossing. The small, wooden building originally contained a small ticket office. This view was taken during the last week of regular passenger services in 1952. (R. E. Vincent/Transport Treasury)

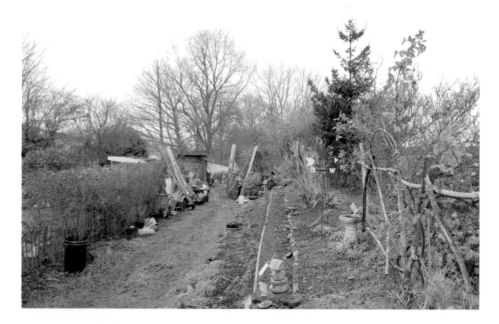

In December 2012 the old platform is now a raised garden. All the old buildings are long gone, and the grassed area is where the track once ran. (James Messer)

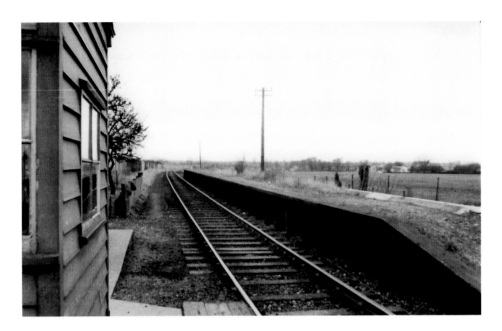

The platform as seen in 1955, some three years after the passenger service had been withdrawn. The platform was 210 feet in length, and was faced with timber to hold back the fill, which consisted of earth and clinker; the wooden building had been demolished. This view was taken adjacent to the ground frame hut and is looking towards Takeley. (Stations UK)

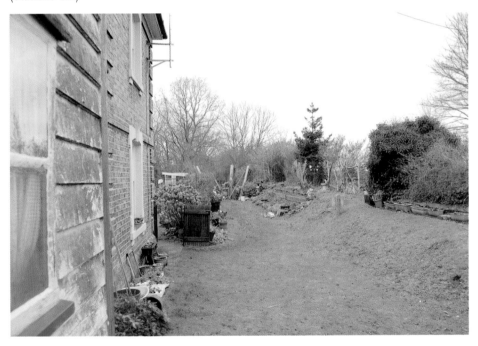

Standing next to the former ground frame hut looking along the garden, with the old platform now just a raised grass-and-flower border. The former level crossing was behind the photographer. (James Messer)

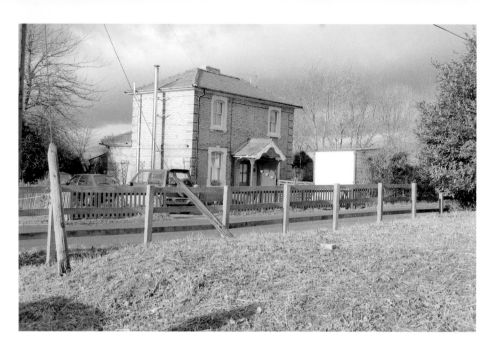

Two views taken in December 2012 of the former crossing keeper's house. The rear of the old ground frame hut can be seen on the right of the picture, and the old level crossing was to the right of the hut. There was also a second level crossing installed in 1942 to serve the US Army's storage facility. Later this was taken over by Geest Bananas as a ripening depot for imported fruit, and it is still a food distribution depot today, with all traffic going by road. The lower view shows one of the original gate posts on the second level crossing. This used to protect the siding leading into the storage depot; today the Flitch Way has diverted around the gatehouse and uses the old siding to gain access back onto the old formation. (Andy T. Wallis)

Dunmow

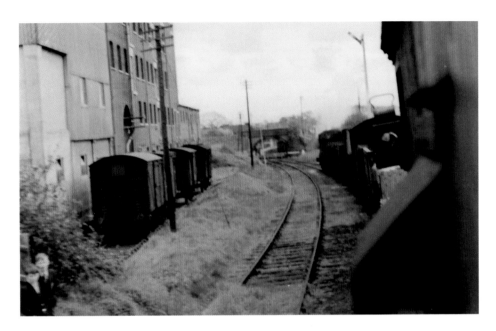

View taken from the brake van of a freight train approaching Dunmow station from the Takeley end on 6 April 1957. The large building on the left is the premises of R. Haslar's corn mills, which generated plenty of traffic for the railway. Out of sight on the right-hand side was the Dunmow Flitch Bacon factory. (Colin Garrett/Photos from the Fifties)

Both factories have long gone, as has the railway, which provided a useful route for the town's original bypass. The brick overbridge in the top view was replaced with a modern concrete structure when the bypass was built. (James Messer)

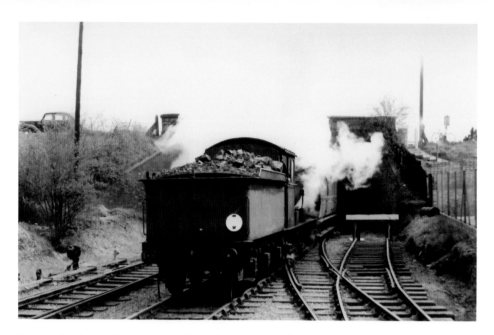

Locomotive J17 and train depart from the station under the main Dunmow to Chelmsford road on 28 April 1956. The photographer is standing on the siding that led to the Dunmow Flitch Bacon factory, and the station was immediately after the road bridge. (Brian Connell/ Photos from the Fifties)

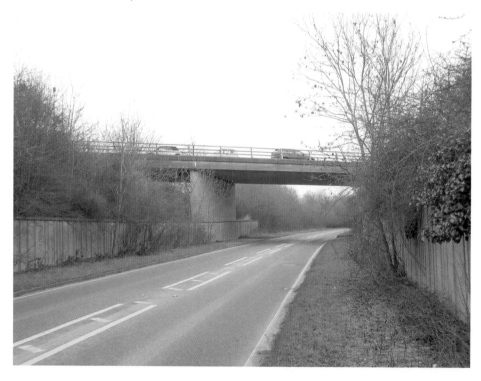

Today's view shows the railway and station completely erased, and replaced with the town's bypass. (James Messer)

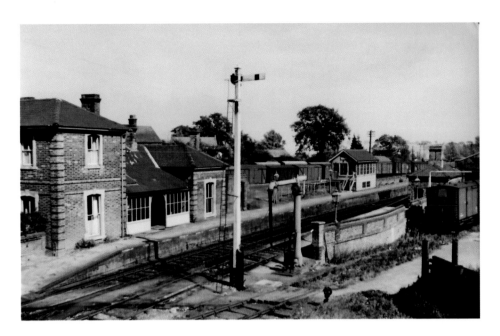

Two similar views taken approximately fifty-seven years apart, the top showing the station on 9 September 1962 during the freight-only era. The station still saw three bank holiday excursions during the spring and summer months, from Broxbourne to Clacton via Bishop's Stortford, Dunmow, Braintree and Witham. The last excursion ran in August 1962. (R. M. Casserley)

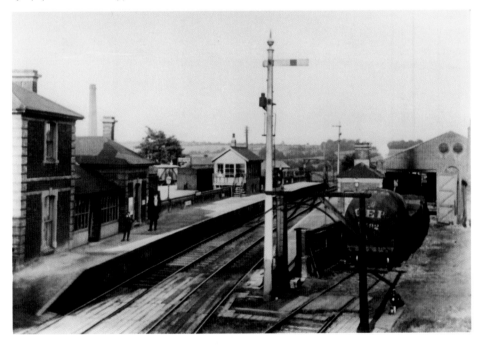

Back in 1905 the station looked very neat and tidy, with plenty of traffic standing in the various sidings. The tall Up starting signal lost its fine finial, and had the lamp matched with the arm in the intervening years. (Historical Model Railway Society)

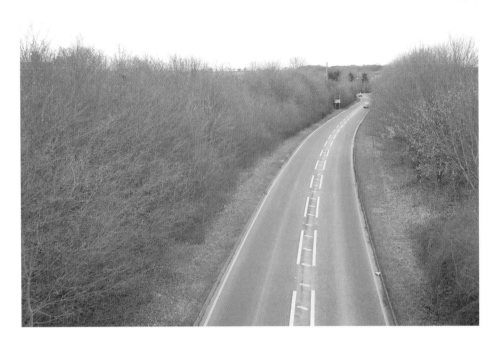

Modern view from the road bridge that used to cross the line at this location. The bypass built in 1979/80 has since been replaced with the A120, benefiting from a multi-million-pound dualling scheme that takes the main road to the south of the town. The old railway followed the road, and then turned away to the right to cross the Chelmer Valley on a viaduct. (James Messer)

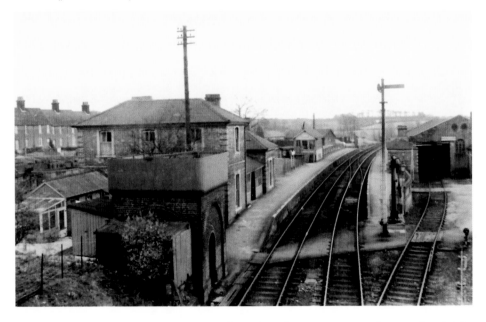

The same view some fifty-seven years earlier when the station was only open for freight and excursion traffic. (Stations UK)

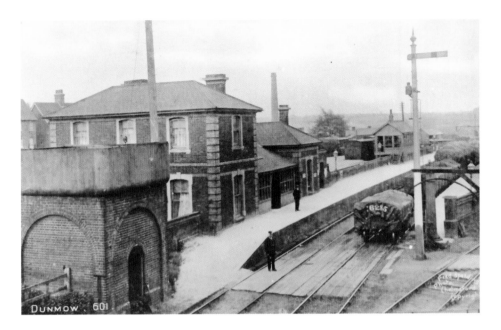

This view was taken way back in the Great Eastern days, and shows the water tower, station house and buildings, and the signal box. A freight train is standing in the Up platform awaiting its locomotive. The houses located behind the station still exist. (Lens of Sutton Collection)

Today a similar view shows the houses that were originally located behind the station. The station yard is now home to some industrial units. (James Messer)

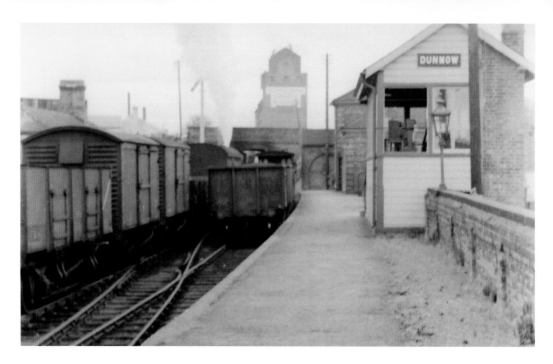

Close-up view of the signal box and a freight train being shunted using both platforms. This view was taken on 6 April 1957. The signal box was built in 1887, and was fitted with a Railway Signalling Company lever frame of some thirty-five levers, with as many as thirty-four working levers during its eighty-year history. The signal box was closed in June 1967, the station finally closing in April 1969. (Chris Gammell/Photos from the Fifties)

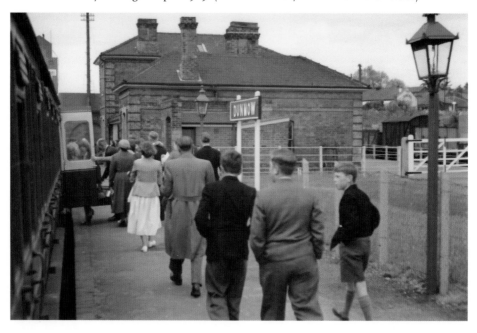

An excursion train calls at the station to pick up the many travellers going to Clacton for a day trip. The date was 20 May 1956. (Brian Connell/Photos from the Fifties)

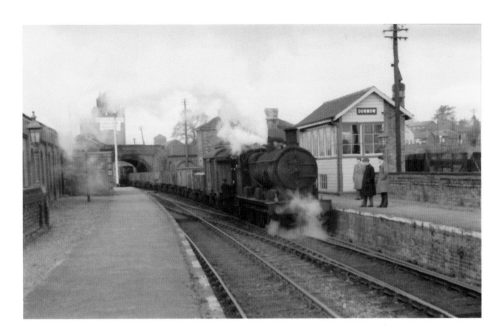

Locomotive J17 65535 arriving at the station with a Down freight working on 28 April 1956. This view, taken from the Up platform, shows the road overbridge in the background, and the tall Haslar's corn mill in the distance. The edge of the large goods shed can be seen on the extreme left of the picture. (Brian Connell/Photos from the Fifties)

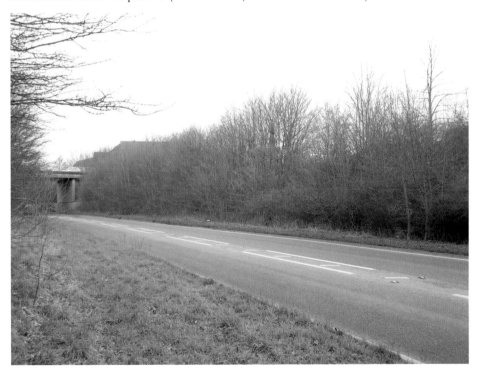

With no old landmarks to help, re-creating this picture is difficult, as even the road bridge has been rebuilt to modern standards. (James Messer)

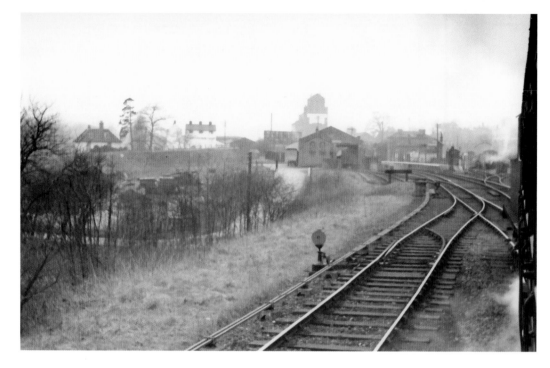

A view, taken from the window of a passenger train on 26 February 1952, of the approach to Dunmow station. The line on the left is the Up refuge siding, the main line being protected by trap points and an old GER-type Dodd (shunting signal). Nearer to the station a connection was provided from the Up loop line to the goods yard. All these connections were worked from the signal box. (R. E. Vincent/Transport Treasury)

Two views of the large electric train staffs that were used on the line between Bishop's Stortford North and Takeley, and also between Takeley and Dunmow. (Mick Barnes)

Felsted

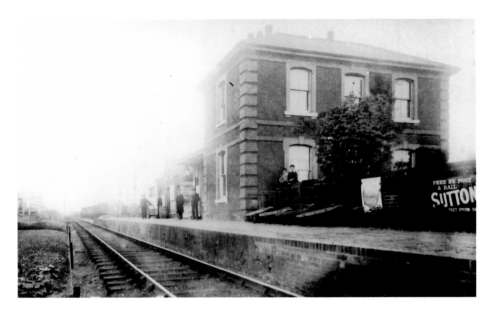

An early twentieth-century view of the station buildings and staff, together with two young lads sitting on the garden wall, all posing for the camera. This view is taken from the cess, looking towards Dunmow. (Lens of Sutton Collection)

For many years the station was lived in and kept in good order but, since the tenant died, the trackbed and surrounding area have been taken over by bushes and tree growth. The upstairs windows of the station house can just be made out through the trees. (James Messer)

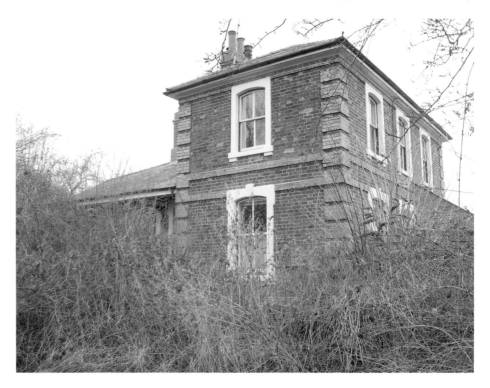

Close-up view of the station building, as seen from the trackbed, looking up between all the vegetation growth. The station was on the market for £100,000, and described as being in need of extensive modernisation. By the time this book is published the station should have a new owner. (James Messer)

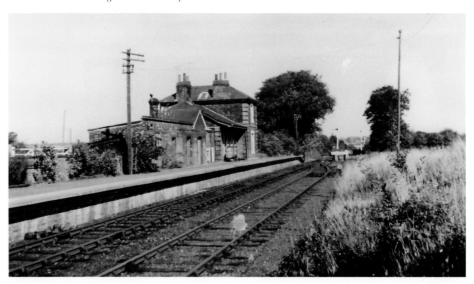

This view is looking towards Braintree. We see the station in September 1962, still looking very neat and tidy, despite not having seen a regular passenger train for the previous ten years. The track in the foreground is the loop that was authorised in 1926 and completed in 1927. (R. M. Casserley)

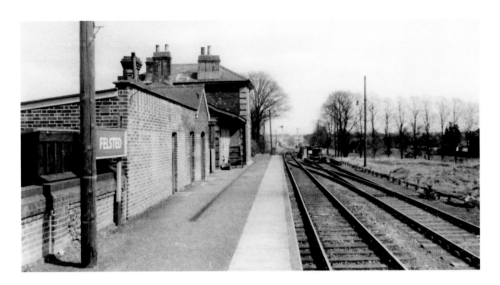

The station in 1955, looking east from the single platform. The station was originally called 'Felstead for Little Dunmow' from the opening in 1869 until it was renamed just plain 'Felsted' in June 1950; why the railway left out the 'a' in the spelling is anybody's guess. The station remained open for general freight and parcels traffic until 4 May 1964. This closure did not extend to the sugar beet sidings; the traffic to and from the factory ended after the 1968/69 crop had been processed, and the line to Felsted closed completely on 1 April 1969. (Stations UK)

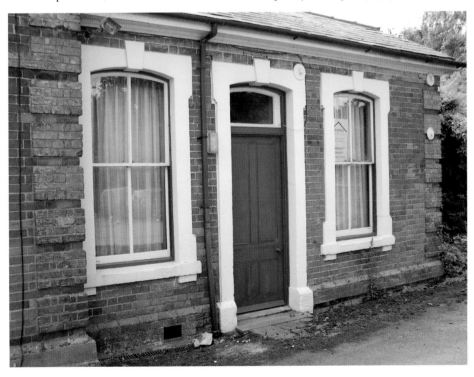

A close-up view of the old booking hall entrance, now a private house. The old platform and trackbed now form the garden for the station house, and are all fenced off with trees having been planted for screening purposes. (James Messer)

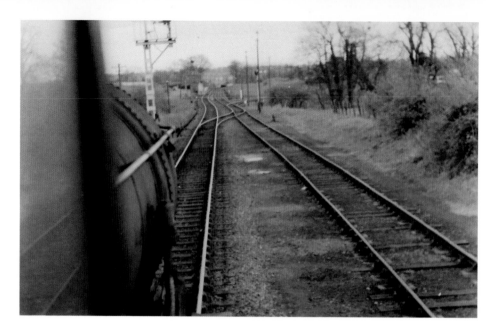

An unusual view from the footplate of a locomotive as it runs into the station. The points in front of the train led into the goods loop, and another connection led into the sugar beet factory. (Chris Gammell/Photos from the Fifties)

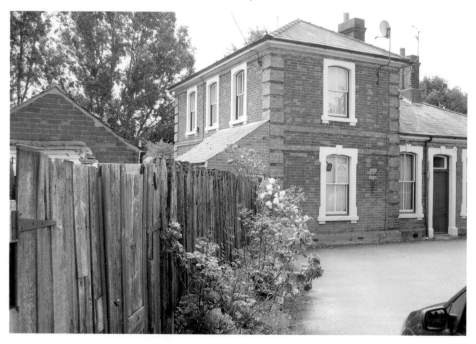

Close-up view of the station house and outbuildings in the garden, which are hidden by the rather dilapidated fence. The house was lived in by former railway employees for a number of years, and the property is now owned by Essex County Council, who purchased it when they bought the former railway land. The station is now about to change hands again, together with the outbuildings and part of the platform, as the plot is for sale. (James Messer)

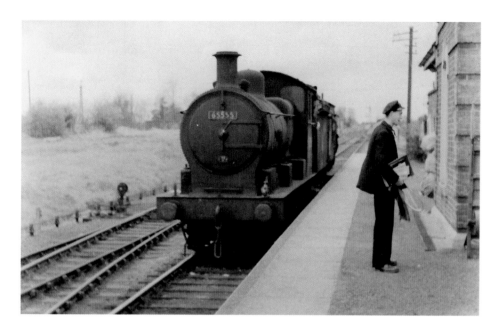

Class J17 locomotive 65555 and brake van stand at the platform whilst a member of staff collects or delivers the mail and token. This locomotive was not fitted with vacuum brakes, and this class of engine regularly worked the freight over the branch. The line on the left is the loop installed in 1926/27. This view was taken 6 April 1957. (Chris Gammell/Photos from the Fifties)

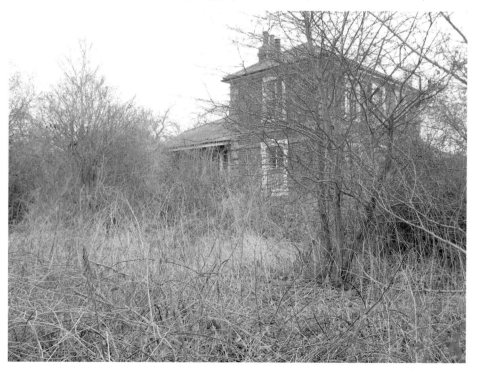

South view of station house and platform buildings, taken from the new housing development, which has been built on the former sugar beet factory site. (James Messer)

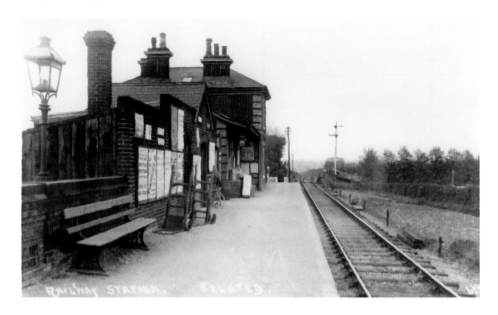

An old Great Eastern Railway view, taken from the platform, looking towards Braintree. At this time the Down starting and the Up home signals were lower quadrants and shared the same post. Immediately after the end of the platform was the Station Road underbridge which carried the main road from Little Dunmow to Felsted village. (Lens of Sutton Collection)

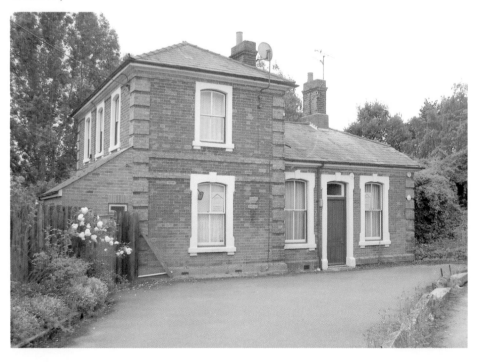

Close-up view of the station in use as a residential home. The former goods yard is now a travellers' site, and the Flitch Way is diverted round this, and continues to the road on a new course. (James Messer)

Bannister Green Halt

View from the road overbridge of the remains of the halt as seen in 1955. The halt was of similar construction to that at Stane Street, with a short, 30-foot platform, filled with clinker up to rail level. A sign and post, with lamp attached, completed the layout. The sign and lamp were removed when the passenger service was withdrawn in 1952. (Stations UK)

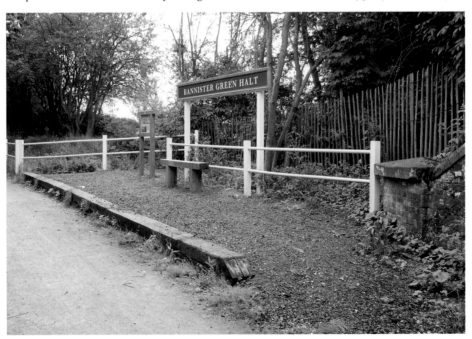

The halt has been rebuilt in the same position as part of the improvements to the Flitch Way. A wooden seat and information board have also been provided. (James Messer)

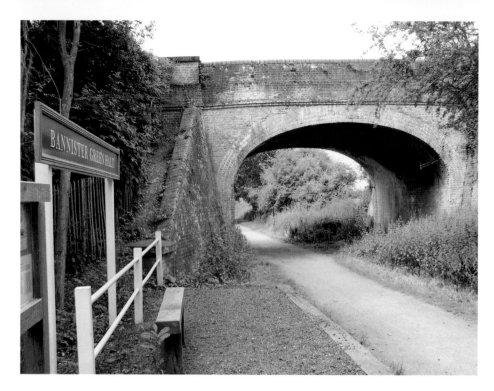

Overbridge No. 2092 with the rebuilt halt on the left. The bridge was known as 'Watch house', and carried the B1417, linking the village with the main A120. This view is looking towards Felsted and Dunmow. The lower view, taken back in 1994, shows the bridge from the other direction looking towards Rayne. (James Messer)

Rayne

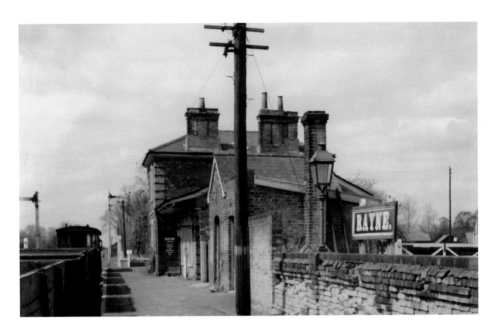

A view of Rayne station with a freight train standing in the platform on 28 April 1954, showing an original telegraph pole, and the signal protecting the level crossing. The station looks fairly clean and tidy considering the passenger train service had been withdrawn some two years previously. (Brian Connell/Photos from the Fifties)

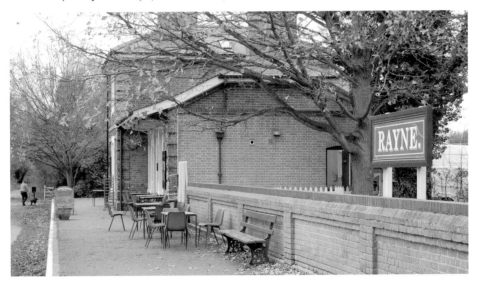

Today the station is the rangers' headquarters for the Flitch Way. There is a small café in the booking hall/ticket office, and the old, separate toilet building has been incorporated into the main buildings. (James Messer)

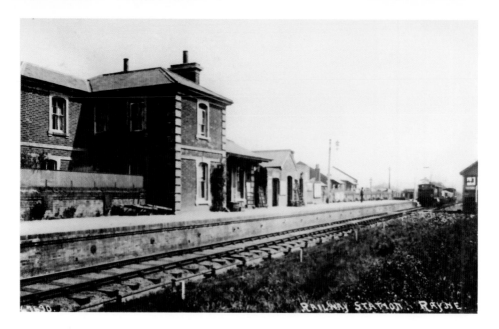

Old Great Eastern Railway view of the station with a freight train arriving from the Braintree direction. The station house had an extension added to accommodate the stationmaster's large family. The small goods yard was at the Braintree end of the station, with a facing connection leading to a long shunting spur to which the sidings were connected. (Lens of Sutton Collection)

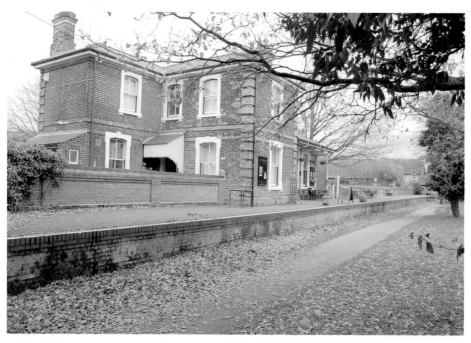

Today the station is used as headquarters for the Flitch Way rangers, as well as providing refreshment and toilet facilities for walkers, cyclists and horse riders. (James Messer)

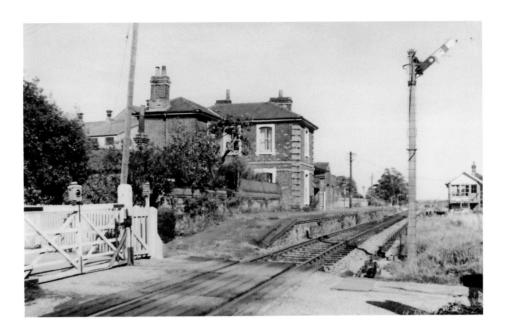

Two views taken 50 years apart. The first was taken on 9 September 1962, the neglect beginning to show on the platforms. In later days the signal box was always switched out except when a train needed to call at the goods yard. The goods yard finally closed on 7 December 1964; the point work was removed the following year, and the signal box was abolished in December 1965. (R. M. Casserley)

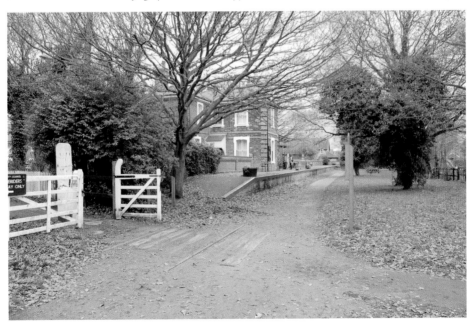

This view was taken in December 2012 from approximately the same position. The station is now the headquarters for the Flitch Way rangers. Everything looks very neat and tidy, and the old rails can still be seen in the ground by the old level crossing. The gatepost has stood the test of time very well. (James Messer)

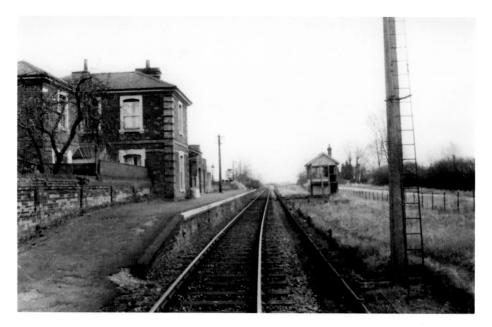

General view looking east towards Braintree, showing the station and signal box as seen in 1955, some three years after the passenger train service had ceased. The signal box stands protecting the level crossing and the connection to the goods yard. (Stations UK)

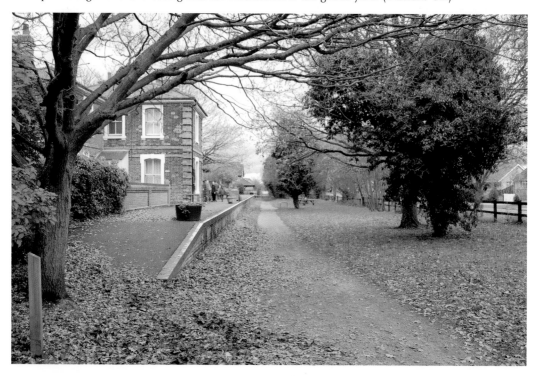

Straight-ahead view looking towards Braintree, showing the restored station house and buildings. The old trackbed has been surfaced with fine stone to make it suitable for walkers and cyclists, and some trees have grown up on the line side. (James Messer)

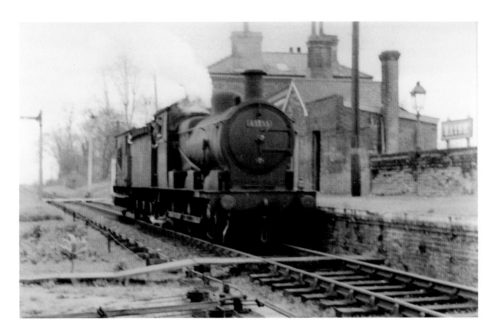

Locomotive 65555 and a brake van stop at the station on 6 April 1957. Rayne goods yard was served by the return working of the morning goods train working from Braintree to Bishop's Stortford. The afternoon working called at Rayne in the Down direction. These two services covered the whole branch although additional paths were available for seasonal sugar beet traffic between Bishop's Stortford and Felsted. (Colin Garrett/Photos from the Fifties)

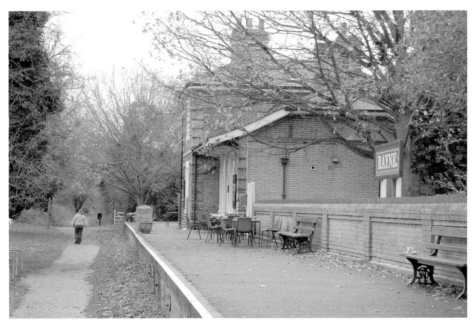

Close view of the buildings and platform taken in 2012. The parcel lock-up and lamp room have been demolished, and the gents toilet has been incorporated into the main buildings. On my visit the station café was doing a roaring trade even in December. (James Messer)

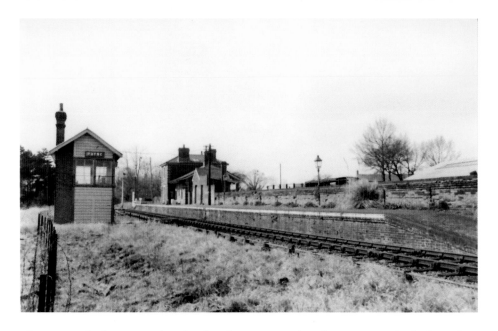

This view is looking towards Felsted and Dunmow, taken from just inside the boundary fence, showing the small signal box on the Up side, opposite the platform. The signal box was equipped with an eighteen-lever Railway Signalling Company lever frame, with thirteen working at its busiest time; at the end of its life this had been reduced to just eight working levers. (Stations UK)

Modern view shows how close the new housing development gets to the railway. This area used to be the old goods yard, and contained a large goods shed and some sidings. (James Messer)

Braintree

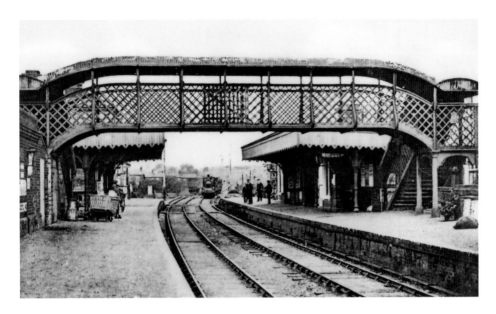

An early Great Eastern Railway view of a train arriving in the westbound platform at Braintree. This view is dated pre-1923 when the station had buildings on both platforms, connected by a footbridge. (Lens of Sutton Collection)

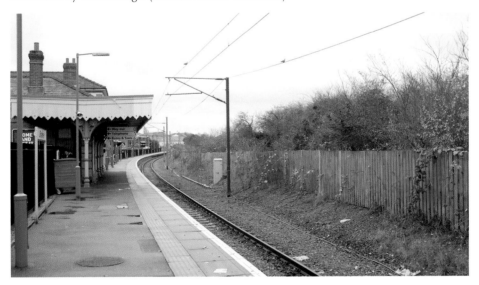

In 2012 the view, taken from a similar position, shows how much has changed over the previous ninety years or so. The station now has a single platform which has been extended a couple of times over the intervening years, and is now capable of holding a twelve-car EMU. The canopy has been slightly cut back to allow clearance for the overhead power lines. (James Messer)

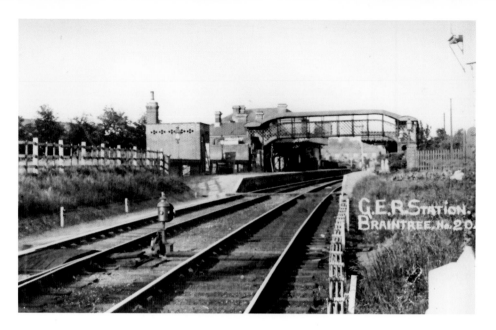

Another GER view of the station, this time taken from the line side at the Dunmow end, looking back towards the platforms. The points just seen in the left of the picture allowed the two running lines to merge into a single line. The left-hand line then continued to form a short carriage siding for stabling of the branch coaches. (Lens of Sutton Collection)

In 2012 all the railway beyond the station has been swept away, and the trackbed forms part of the car park, beyond which the Flitch Way commences. (James Messer)

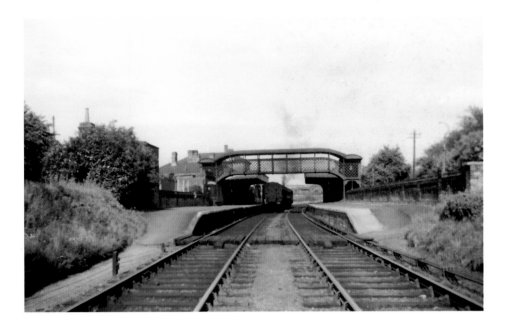

A view, looking towards the station on 26 May 1956, from the track at the Felsted end of the layout, with the main platform on the left. A train is waiting for departure towards Witham. At this time the footbridge and second platform were fully intact, the passenger train service to Bishop's Stortford having been withdrawn some four years earlier. (R. M. Casserley)

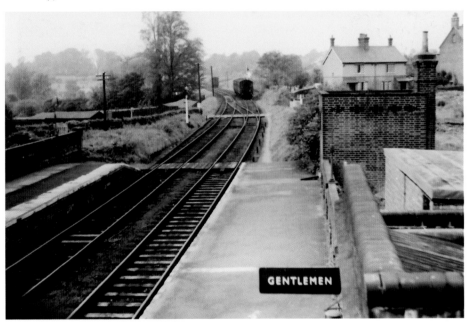

GENTLEMEN

A view, looking the other way back towards Rayne, taken from the footbridge. Passenger coaches can be seen stored in the head shunt on the right, and the footpath crossing in the background was a favourite location for photographers. (Brian Connell/Photos from the Fifties)

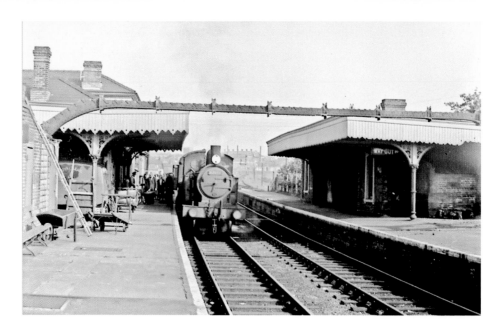

A view from around 1956 of the station with the footbridge in the process of being cut up for scrapping. The next possession would see the last steel removed. The train in the platform has just arrived from Witham and, once the locomotive had run round, its train would work the return service. (Brian Pask)

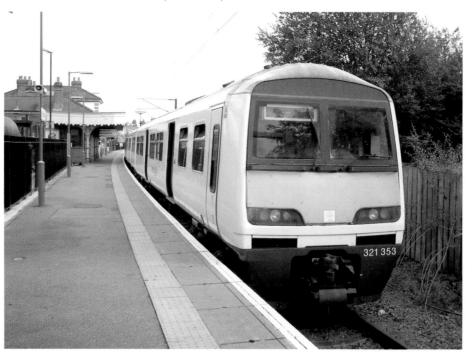

Moving forward some fifty-seven years we see the modern EMU 321353 standing in a similar position on the single platform. Modern lighting and public address system, together with a modernised building, make for a pleasant station. (James Messer)

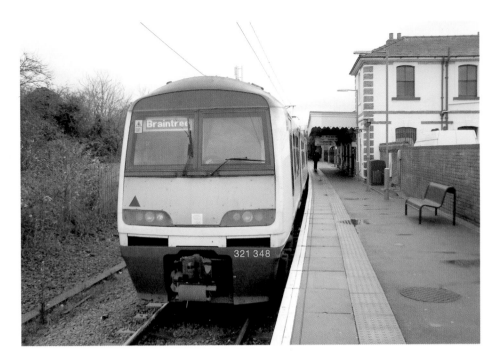

Modern view of the station today with EMU 321348 standing in the platform awaiting departure. During the week most trains run to and from Liverpool Street, but on Sundays there is a shuttle service to Witham. Note the station building has been tastefully renovated. (James Messer)

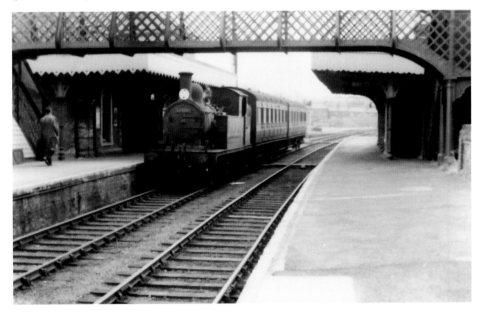

Turning the clock back over sixty years we see an LNER Class F5 locomotive 67188, having arrived in the Witham-bound platform with a two-coach train during the 1950s. The locomotive would detach and run round its coaches ready for its next working. (Lens of Sutton Collection)

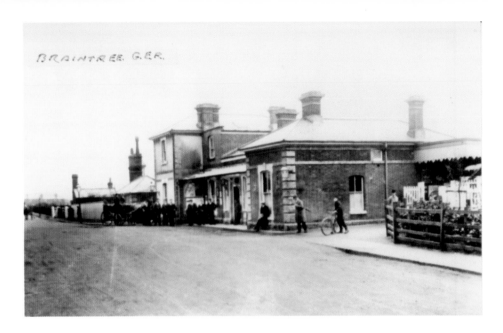

External view of the station taken in the GER era with a horse and coach standing outside awaiting the arrival of a train. The roadway seems to be made of stone, with carriage tracks clearly marking the surface. There seem to be plenty of people or staff waiting outside the station. Note the early pushbike on the right of the picture. (Lens of Sutton Collection)

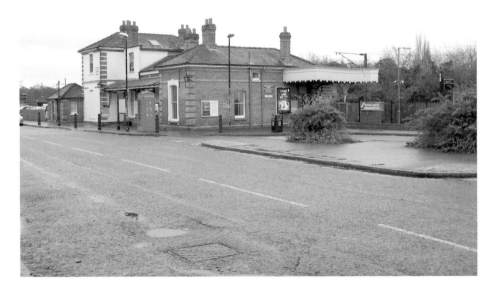

On a dull day in 2012 we can see how little has really changed as far as the station buildings are concerned; the chimneys have received pots, and a couple of advertising boards are attached to the walls, together with a telephone box. The road now has a metalled surface. (James Messer)

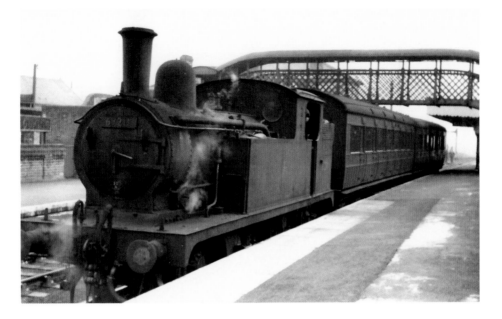

Locomotive of LNER Class F5 67211 stands at Braintree with a two-coach train for Bishop's Stortford, seen here on 26 February 1952 during the last week that passenger services ran on the cross-country route. The passenger service was withdrawn on 1 March, although the line remained open for freight traffic. (R. E. Vincent/Transport Treasury)

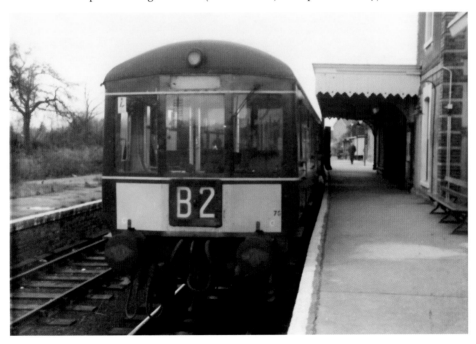

Some fifteen years later, steam trains had been withdrawn, and the Braintree branch had seen replacement railbuses later replaced with two-car DMUs. In this view we see a Gloucester type DMU standing in the platform, waiting to depart back to Witham. Note the platform buildings on the other line had been demolished, as had the footbridge. (Dickie Pearce)

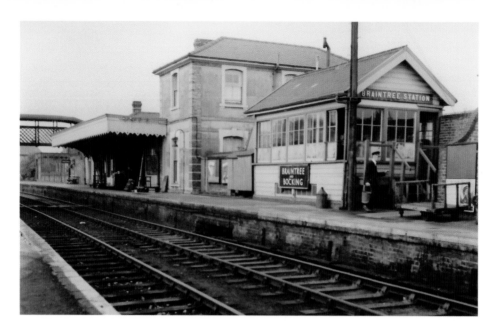

General view of station taken from the Dunmow-bound platform, showing the signal box, station house and buildings, canopy and edge of the footbridge. Note the large enamel Braintree and Bocking sign on the front of the signal box, this view dated *c.* 1954. (Brian Connell/Photos from the Fifties)

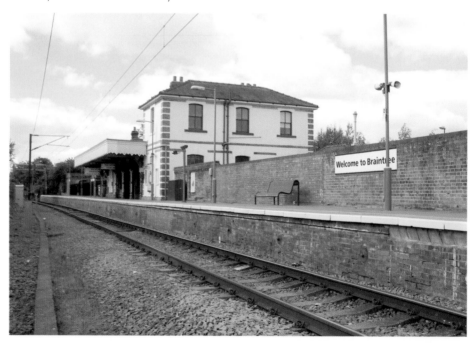

A 2012 view taken from a similar position. The second platform had been demolished by this time and the track had been lifted in 1970. The signal box had closed in June 1977 when the line was resignalled prior to electrification. The station buildings, now Grade II listed, have been refurbished. (James Messer)

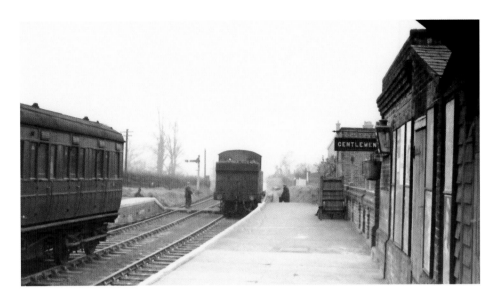

Locomotive running round its train at Braintree on 26 February 1952, just a few days before the cross-country service was withdrawn. Special passenger workings on bank holidays would continue to run over the line from Broxbourne and Bishop's Stortford to Clacton via Dunmow and Witham. There were also end-of-term specials to Felsted for the large boys' school located in the village. (R. E. Vincent/Transport Treasury)

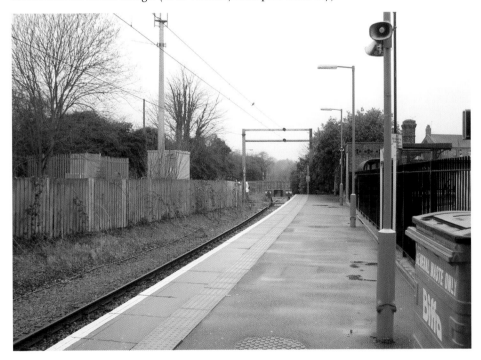

Today the railway ends at the buffer stops at the end of a slightly extended platform. The second platform has been completely demolished, together with its associated track. Had it not been for a local campaign Braintree would also have been a casualty of the Beeching cuts. (James Messer)

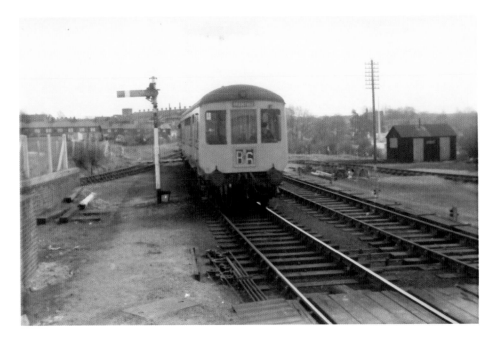

Gloucester type DMU enters the station from Witham in 1966. By this time two-car DMUs had replaced the railbuses, which could not accommodate the increased passenger loadings. The threat of closure was lifted in September 1966, subject to continued growth. The statistics make interesting reading, with only 153,000 journeys being made in 1962, while by 1972 this had risen to 427,000 passenger journeys; by 1975 this had increased further to 575,000, which warranted the electrification project. (Dickie Pearce)

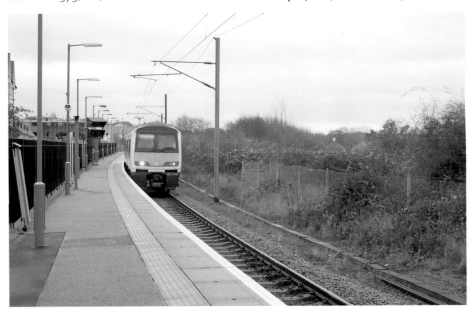

Some forty-five years later a Class 321 provides the motive power for most trips on the branch. Earlier types of EMUs on the branch included units from the Class 305s and 308s, all now withdrawn from service. (James Messer)

Braintree Goods Yard

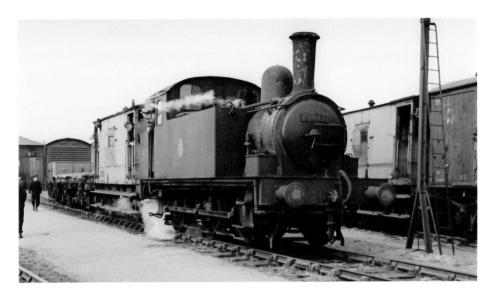

Locomotive J68 68662 is seen shunting in Braintree goods yard on 28 April 1956. The station had a large layout with sidings adjacent to the (new) main station. The old station site became the main goods yard when the new through station was opened with the Bishop's Stortford line in 1869. (Brian Connell/Photos from the Fifties)

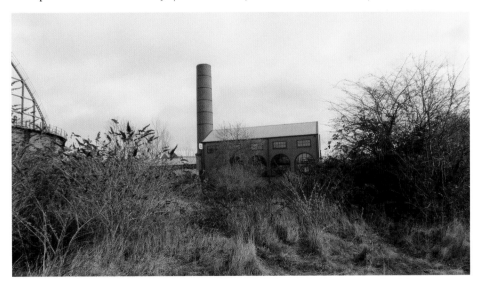

General freight facilities were withdrawn from the goods yard on 1 August 1978. This left only the fertiliser train, which ran once a week for the next ten years. The traffic ceased in the late 1980s, when the distribution depot for the fertiliser closed. This view shows one of the former industrial buildings having been tastefully converted to living accommodation after the former railway and industrial land was redeveloped. (Paul Lemon)

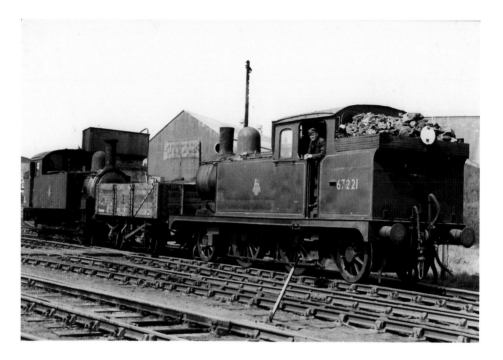

Two locomotives stand in the goods yard awaiting their next working. On the left is a Class J68 and on the right is Class F6 67221. Class F5 locomotive 67211 had the honour of hauling the last regular passenger train between Braintree and Bishop's Stortford and return on Saturday 1 March 1952. This locomotive was withdrawn from traffic in October 1956.

This photograph was taken from the exact spot of the previous picture; the old goods yard and station site has now been redeveloped with new housing. (Paul Lemon)

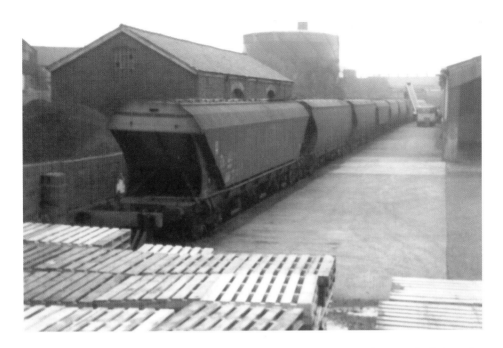

Trial bulk-loading of a freight train at the yard in 1983. The building on the left is the granary, and the large goods shed is out of view to the right. There were many users of the goods yard in the 1950s, including Lake & Elliott and Crittall, who sent out their windows by rail. By 1974 all this activity had ceased, leaving just the fertiliser traffic, which used to arrive once a week by train from Ince in Cheshire. (Wayne Claydon)

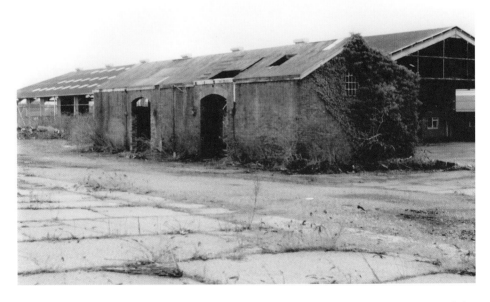

The fertiliser traffic finished in the late 1980s, and the rail facilities were closed and the remaining sidings lifted. By the mid-1990s the old granary was beginning to look the worse for wear. The purpose-built fertiliser depot stands empty behind it. (James Messer)

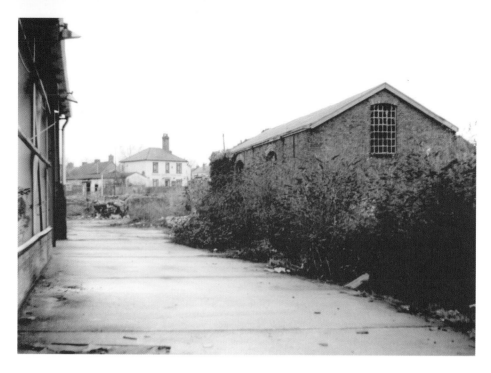

Nature takes hold of the former siding adjacent to the granary, as seen in the mid-1990s waiting for the demolition men to arrive. The fertiliser depot stands empty, awaiting its fate, as does the former cattle dock, with its railways, as seen in the lower picture. The whole area is now given over to housing, as shown in the picture on page 58. (James Messer)

Braintree Freeport

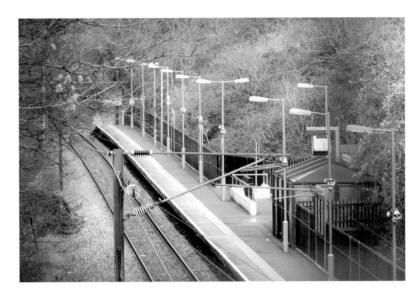

A purpose-built station consisting of an eight-coach single platform opened in 1999 to serve the local 'Freeport shopping complex'. To prevent the parking being used by commuters peak time trains do not stop. This view is taken from a new footbridge that crosses the line to link new housing with the station and 'Freeport'. (Paul Lemon)

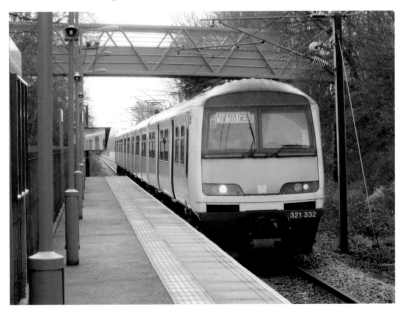

Unit 321332 arrives at the station on a Saturday morning in February 2013. This view is looking south towards Cressing. (Paul Lemon)

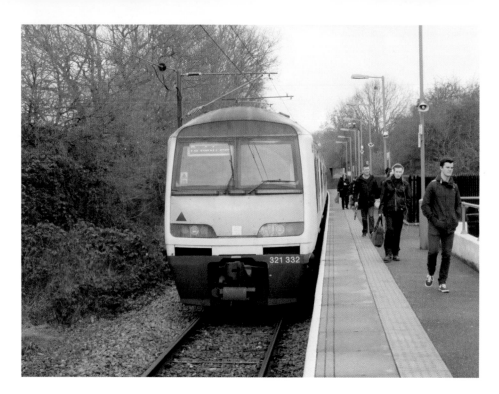

The four-car Class 321 empties out at 'Freeport' during a Saturday in February 2013. The station is equipped with look-back mirrors for driver-only operation of the train service. There is no ticket office; tickets can be purchased from a platform-mounted machine or on the train. The ticket machine and waiting shelter can be seen in the lower view, and the footbridge was erected in 2012. (Paul Lemon)

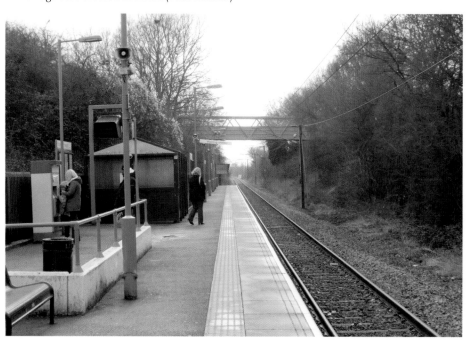

Cressing

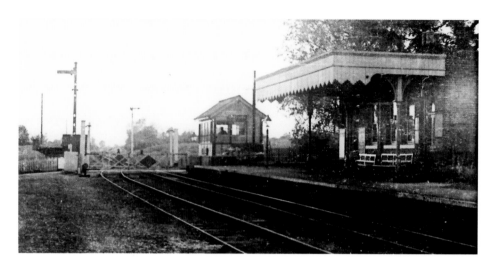

A poor view of the station and adjacent signal box, together with the Up starting signal and the Down home and level crossing gates. The signal box was fitted with a twenty-lever McKenzie & Holland lever frame, with some fifteen working levers at its busiest. After the goods yard was closed and the siding lifted the signal box was downgraded to a gate box, with only five working levers. Between 1931 and 1966 Cressing was a block post, the line being controlled by a miniature electric train staff. (Stations UK)

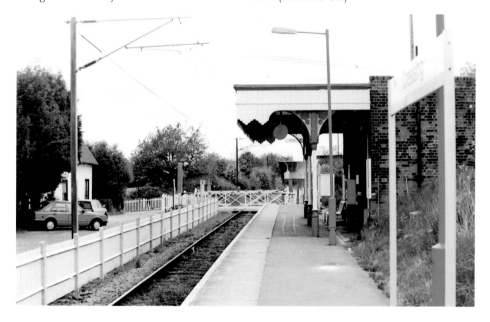

Station view, taken looking towards Braintree, with the level crossing still in possession of its gates. The gates and signalling were controlled from a small panel in the booking office. (James Messer)

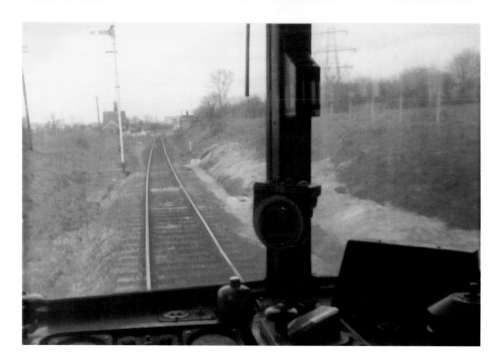

View from the rear cab of a DMU as it departs from Cressing towards Witham in 1967. By this time the siding and goods yard had closed. The Down home semaphore protected the level crossing and would continue to do so until 1977, when the line was resignalled. (Dickie Pearce)

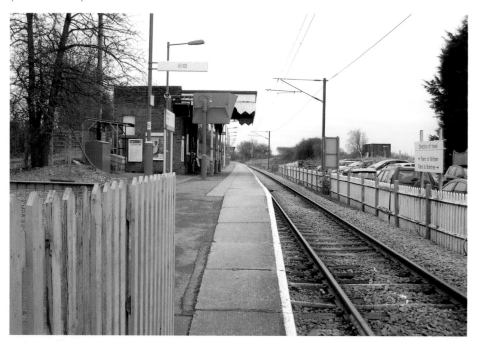

Unable to get a modern view from the train, we have an alternative, looking from the platform at the buildings. The former siding is now the car park. (James Messer)

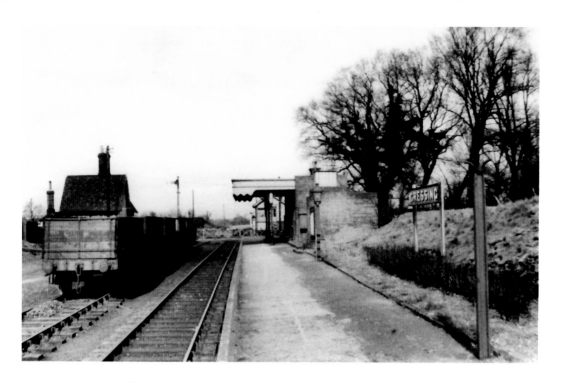

A 1955 view of the station, looking towards the level crossing and Braintree. Several wagons are in the single siding opposite the platform. At this time Cressing was a block post, and all drivers would receive or collect a miniature electric train staff to Witham or Braintree as required. (Stations UK)

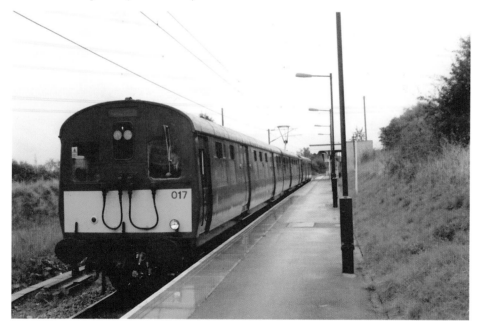

Veteran Class 306 EMU, in use on the branch, calls at a wet Cressing on a special working in connection with Braintree Gala Day on 19 September 1993. (James Messer)

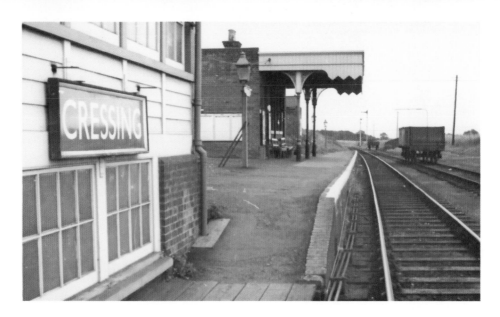

An undated view of the station, looking towards Witham. At this time the station was still fully signalled, with the siding intact. The large 'Cressing' sign attached to the front of the signal box was saved when the signal box was closed and relocated, complete with its 1891 lever frame, to the Colne Valley Railway in 1977. (CVRPS Collection)

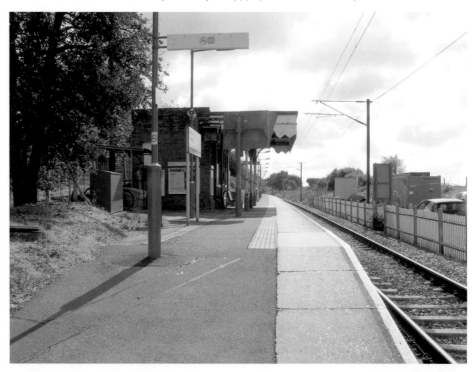

A similar view taken from the platform ramp. The buildings have survived whilst the old semaphore signals and siding are long gone. The old siding and goods yard are now a car park. (James Messer)

Sixty-one years separate these next two pictures. The first was taken from the train as it approached the platform on 26 February 1952; the signalman waits to change tokens at the end of the platform. The stylish old lamps have been replaced with modern, tall, electric examples; otherwise not much has really changed. (R. E. Vincent/Transport Treasury)

In 2013 a similar view shows how improvements from electrification included raising the platform to standard height, together with the installation of the overhead power lines. (James Messer)

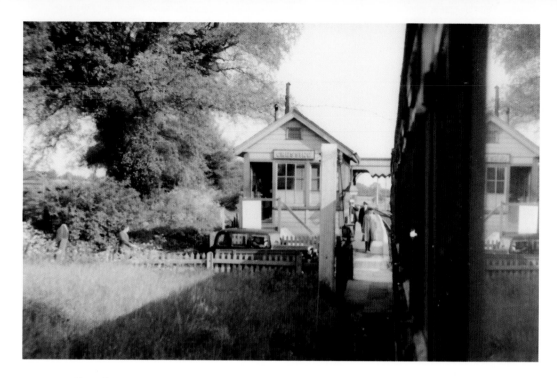

A reflected view, taken from the carriage window, of the train departing from Cressing station, showing the signal box, and a car waiting at the level crossing, which had to be unlocked and then opened by hand by the signalman. The manual gates at this location lasted well into the 1990s before being replaced with modern barriers. (H. C. Casserley)

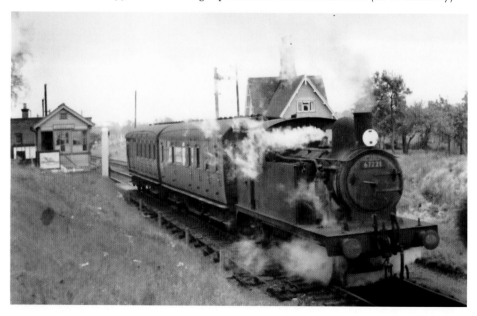

Taken from the embankment just north of the station, this photograph shows Class F6 67221 departing for Braintree with a two-coach train on 18 May 1957. The following year the steam-hauled service was replaced with a diesel railbus. (R. C. Riley/Transport Treasury)

White Notley

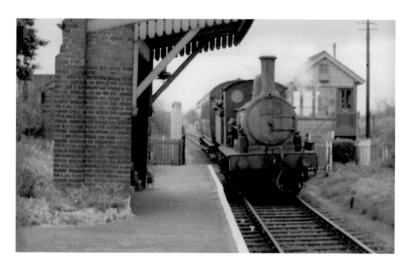

A local branch line working hauled by Class J15 locomotive 65417 enters the station over the level crossing on 6 April 1957. The signal box was used by the crossing keeper and still controlled the gate locks and working distant signals; the small waiting shelter protected any intended passengers. The platforms were of a sub-standard height, and a small step of steps was kept to assist passengers in alighting and boarding trains. (Chris Gammell/ Photos from the Fifties)

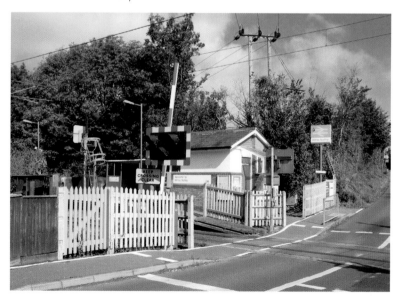

Modern view of the station and level crossing. An automatic barrier-type crossing was installed in the 1990s, replacing the old wooden gates. (James Messer)

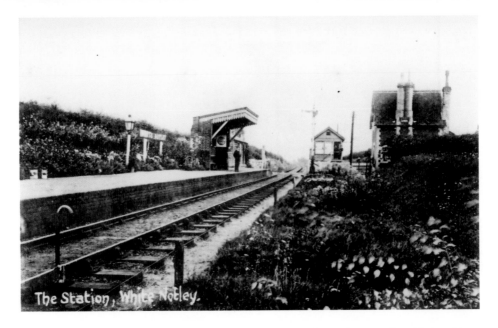

The Station, White Notley.

A very early view of the station, taken looking towards Witham, showing the old signal box, waiting shelter, and lower quadrant semaphore signal protecting the level crossing. The building on the right was used by the railway for staff accommodation. (Lens of Sutton Collection)

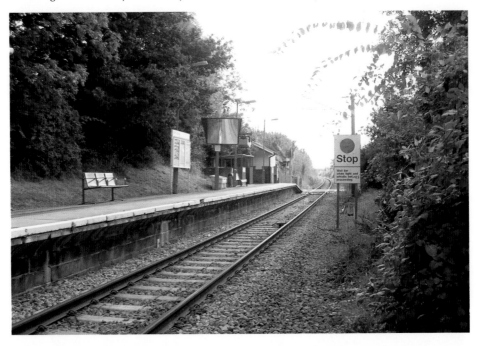

Modern view of the station with the platform now rebuilt to the standard height and also extended to take eight-coach trains. The wooden level crossing and associated colour light signals were abolished in the 1990s to be replaced by an automated crossing. The board on the right instructs the driver to 'Stop' and wait for his white light and whistle before proceeding. (James Messer)

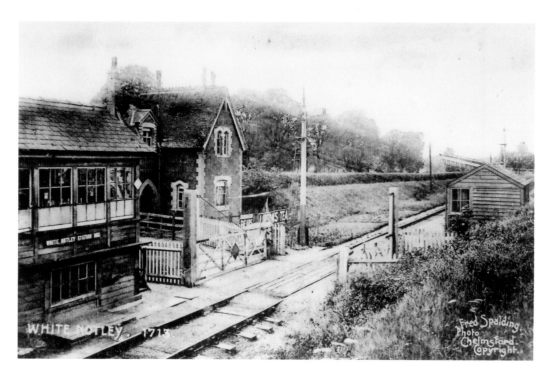

Close-up view of the signal box, level crossing and station house looking north. The signal box was closed as block post in the 1930s, but was retained by the crossing keeper to work the distant signals and gate locks. This method of working survived until the branch was resignalled in the 1970s prior to electrification. (Lens of Sutton Collection)

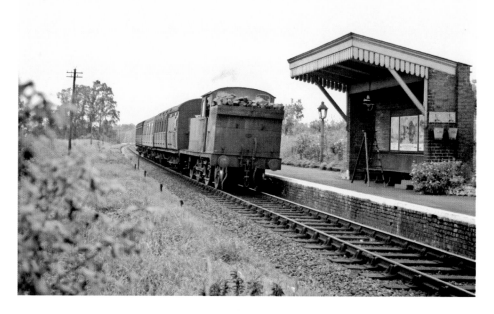

In this 1956 view a local passenger service slows to a stand at a tiny station. There seem to be no passengers waiting for this service. (Brian Pask)

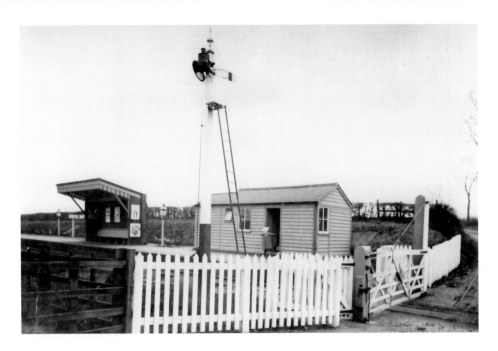

Great Eastern view of the station building, waiting shelter and stop signal protecting the crossing. Apart from the loss of the signal in the 1930s this view remained the same until the 1970s. (Lens of Sutton Collection)

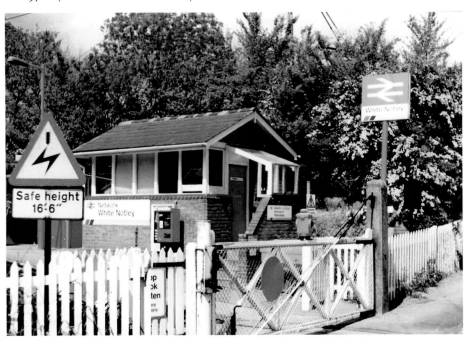

A similar view taken in 1994 with the replacement staff accommodation building. Prior to privatisation of the railway the station staff operated the level crossing, as required, and also sold tickets for intending passengers. The gates were replaced by Railtrack in 1997. On completion the last staff were withdrawn from the station. (James Messer)

Witham

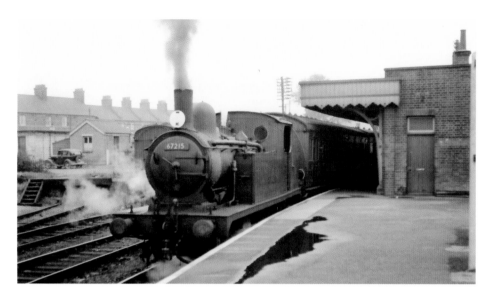

Locomotive Class F5 67215 stands with a Maldon train in platform 1 at Witham in 1954. This class of locomotives worked for many years on the two branches, and had the unfortunate nickname of 'Gobblers', due to the amount of coal required to make them steam. They had a wheel arrangement of 2-4-2. (Brian Connell/Photos from the Fifties)

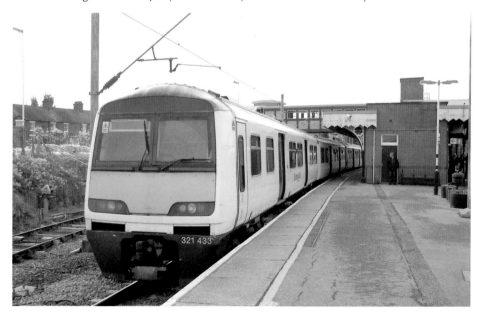

An unusual combination of a Class 321 and Class 317 reverse in the platform at Witham whilst running empty on test run. The canopy and houses in the background are common to both pictures. Over the years some of the trackwork has been removed. (James Messer)

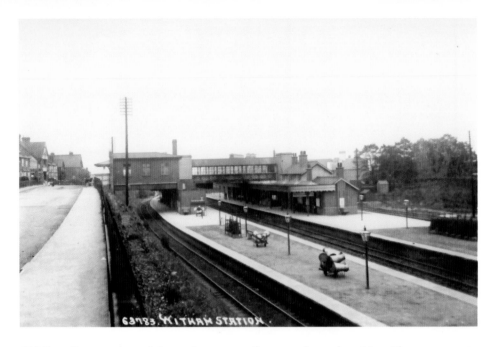

Old Great Eastern view of the station as seen from an elevated position. There appears to be a barrow of empty milk churns awaiting collection on the Down island platform. The buildings and footbridge have changed very little. (Lens of Sutton Collection)

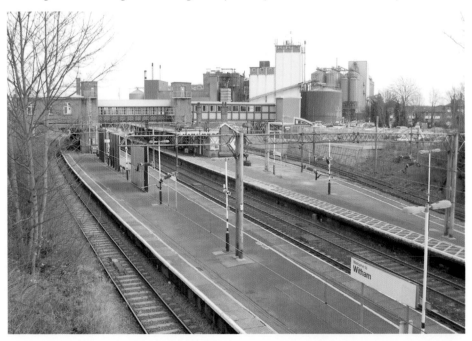

Today the same view shows modern lighting, plus the overhead stanchions, and the station footbridge has been extended over platform 1 to give direct access to the station car park. The large buildings in the background make up a maltings, which used to provide traffic for the railway; now it all goes by road. (James Messer)

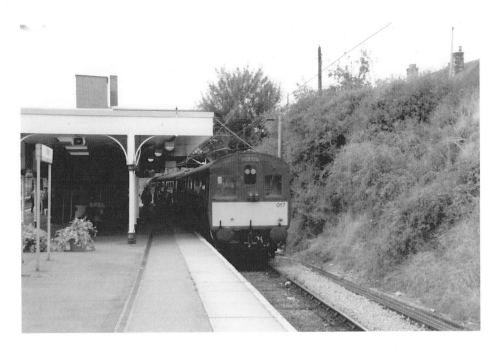

Vintage, preserved Class 306 EMU stands at platform 4 on a special working to Braintree on 19 September 1993 in connection with Braintree Gala Day. Vintage buses were also running between Braintree and the Colne Valley Railway. These units were built originally for the then-new electric service between Liverpool Street and Shenfield. They saw more than thirty years of service before being replaced. (James Messer)

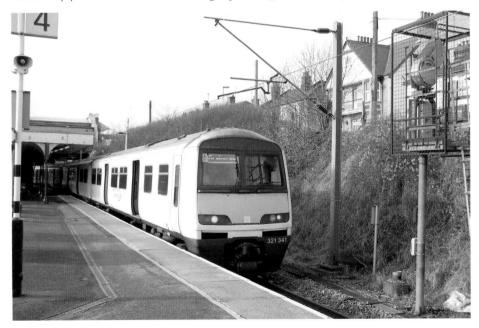

Modern EMU 321341 stands waiting to depart for Braintree in 2012. Most trains now run between Braintree and Liverpool Street, with a shuttle service between Braintree and Witham on Sundays. (James Messer)

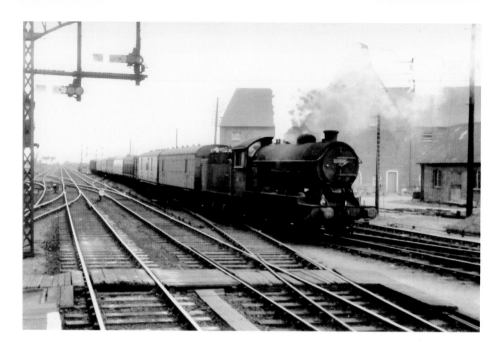

Class J39 locomotive enters the station with a train of mixed vans on 6 April 1957. This view, taken from the Down island platform, is looking towards Colchester. (N. C. Simmons/ Photos from the Fifties)

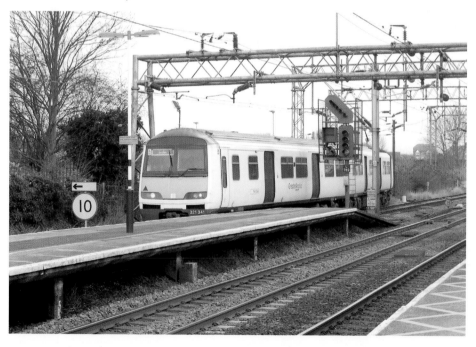

In contrast this picture, taken from the Up island platform, sees a Class 321 entering the station from Braintree. The sharp curve away from the main line is reflected in the 10 mph speed restriction. There was a similar curve on the Maldon line, and this was restricted to 8 mph. (James Messer)

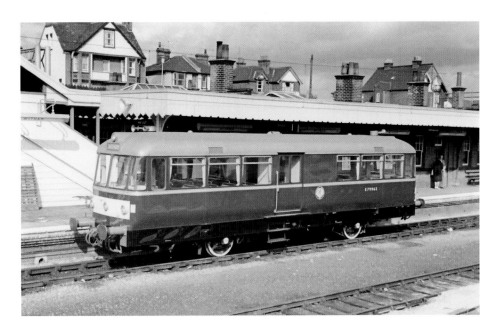

The branch line saviour was to be the diesel railbuses introduced from 1958. They seated fifty-six people and did help reduce costs on the branch lines that they operated on. These German-built machines operated on both the Maldon and Braintree branches. By 1963 a two-car DMU had replaced the railbus on the Braintree line due to increased passenger use; they remained in use on the Maldon line until the passenger service was withdrawn in 1964. Four of the five railbuses are now preserved. (Alec Swain/Transport Treasury)

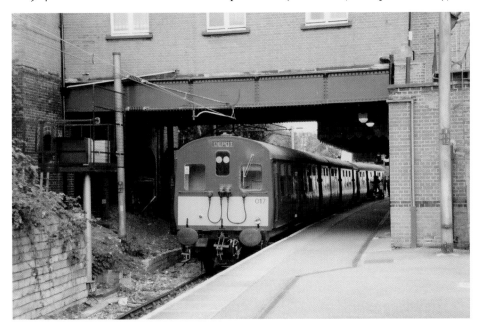

Preserved Class 306 EMU stands at Witham after spending the day working the Braintree shuttle. These were the first units built for the opening of the London to Shenfield electrification in 1949. (James Messer)

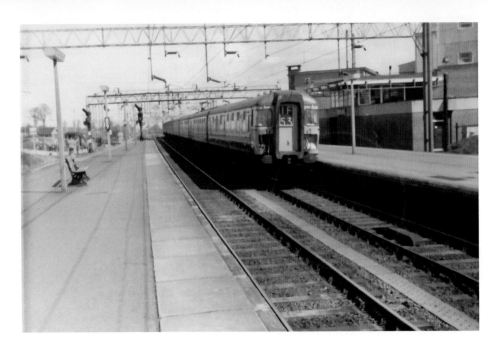

When the missing piece of the Great Eastern electrification, between Chelmsford and Colchester, was completed, it was then possible to travel from Liverpool Street to Clacton by electric train. The Class 309s were introduced to run between Clacton/Walton and London, and an early example is seen entering Witham in the mid-1960s. (Dickie Pearce)

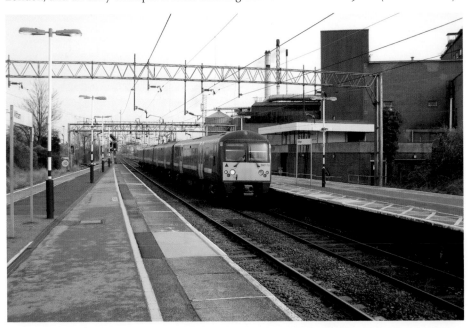

The latest example of EMU Class 360 enters the station in 2012. A few changes have taken place in the intervening forty-five years: the signalling renewed in the 1990s is now controlled from Liverpool Street, and the out-of-use 1960s power box is to the right of the train. (James Messer)

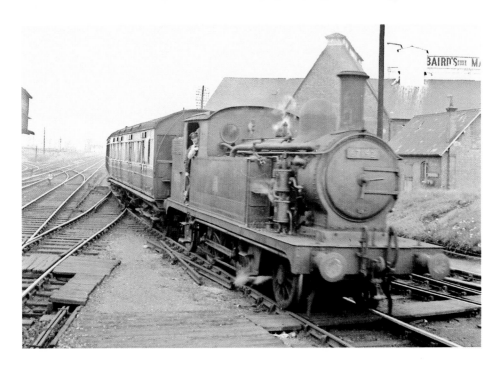

Mid-1950s view of the Maldon branch train arriving, having negotiated the sharp curve around the edge of the malting with Class F5 locomotive in charge. The edge of Witham Junction signal box can be seen on the extreme right of the picture. (Brian Pask)

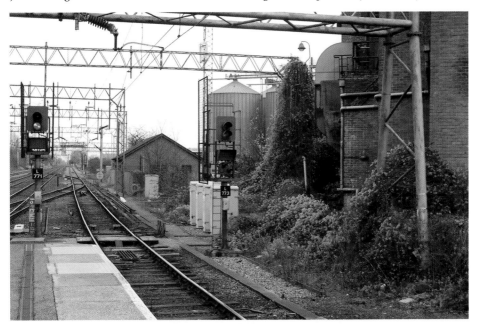

During a quiet moment in 2013 the same view is seen. Changes include electrification, platform lengthening, and the complete eradication of the line to Maldon. The branch used to curve sharply away between the overhead portal mast and the grain silos on the right of the picture. (James Messer)

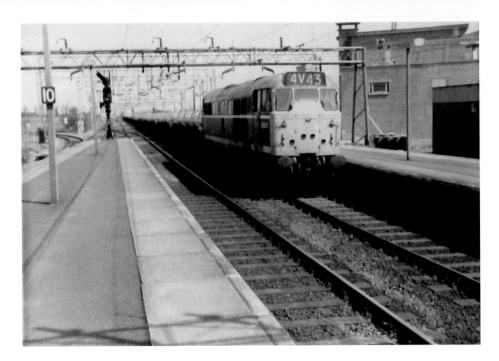

Class 4 Freightliner train passes through the station hauled by a Brush Type 2 diesel later Class 31 in the mid-1960s. This train was allowed to run up to 75 mph. At this time the Maldon branch had recently lost its freight service and was awaiting demolition. The Braintree line can be seen curving away on the left of the picture. (Dickie Pearce)

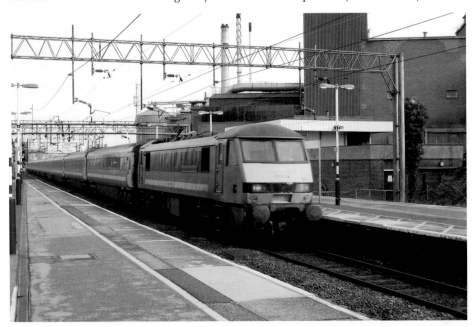

The latest electric locomotive, hauling Mk3 coaching stock, passes through the station on a Norwich to London service. The line speed at this location is 100 mph on the main lines, hence the yellow warning markings on the edge of the platforms. (James Messer)

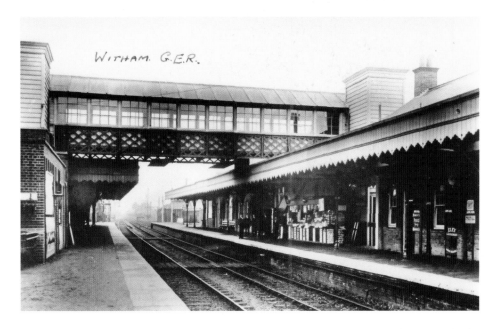

Pre-1923 Great Eastern Railway view of the footbridge and Up side buildings, with the original bookstall on the platform. Note the metal plates under the footbridge to deflect the blast from locomotive chimneys. (Lens of Sutton Collection)

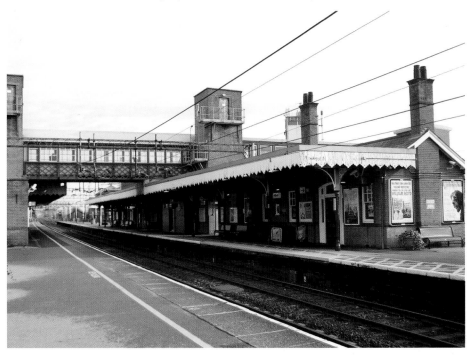

Some ninety or more years later the same view is reproduced with just a few alterations, namely electrification and platform lengthening to take today's much longer trains. One can still change here for trains to Braintree, but unfortunately not for Maldon unless you travel by bus or car. (James Messer)

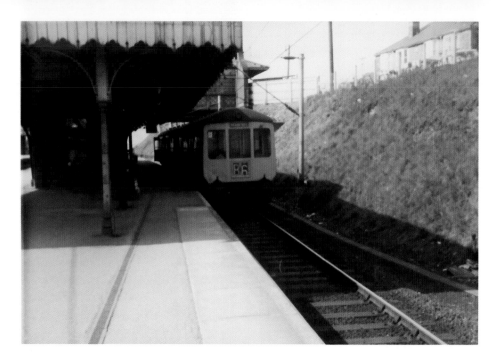

Gloucester type DMU stands at the station in 1967 awaiting departure to Braintree. By this time the threat of closure had been lifted from the passenger service, provided growth continued, which it did, eventually leading to electrification of the branch some ten years later. (Dickie Pearce)

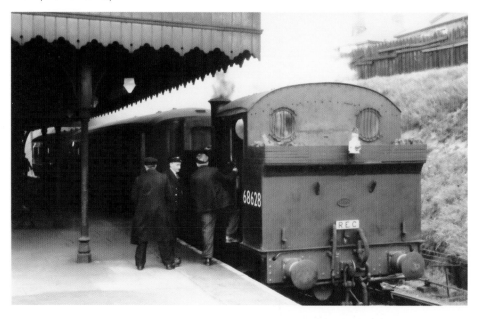

Some ten years previously an 'REC' special train is awaiting departure to Maldon and other destinations on 6 April 1957. The locomotive is Class J69 68628. The main differences between the two pictures were electrification and the wooden fence, which has been replaced with a concrete post and wire fence. (N. C. Simmons/Photos from the Fifties)

Wickham Bishop's

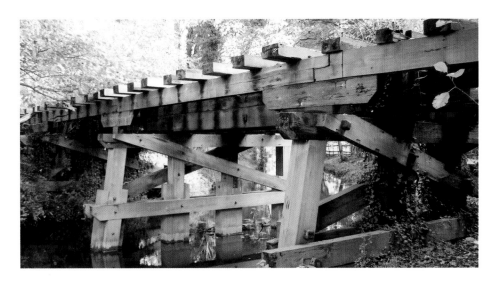

The wooden viaducts that took the branch over the River Blackwater always governed the type of locomotives that could use the branch. They survived the closure of the branch and demolition in 1969, and in 1995 they were placed in the care of Essex County Council. Now scheduled as an ancient monument the viaducts were restored with help from English Heritage. In 1993 the remaining portions of the branch not yet sold were bought by Essex for conversion into a path to be known as the Blackwater Rail Trail. This view is of the restored viaduct as seen in 2012. (James Messer)

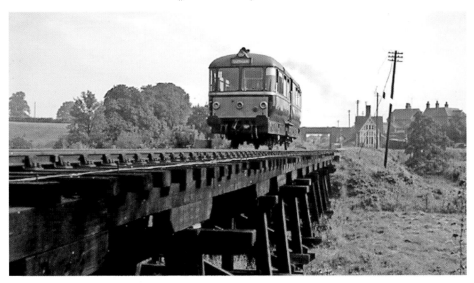

A diesel railbus accelerates away from the station across the viaduct in the early 1960s. At this time there were considerably fewer trees and line side vegetation which allowed this early colour to capture the distant station. (Brian Pask)

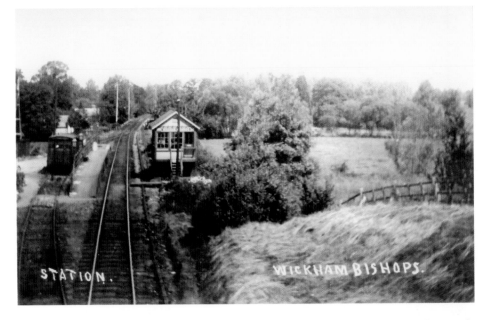

An old Great Eastern view of the station, taken looking north towards Witham. The signals appear to both be 'off' indicating the signal box was switched out of circuit. The station was unusual in having an island platform reached by crossing over the goods siding on the level. (Lens of Sutton Collection)

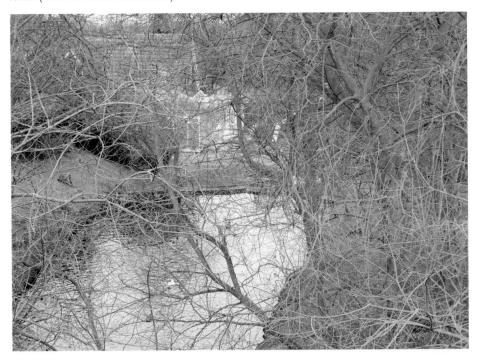

Hidden by the winter foliage the former station is now a much altered private house. The old platform still survives, however there appears to be a man-made pond set in the former trackbed between the old station and former road overbridge. (James Messer)

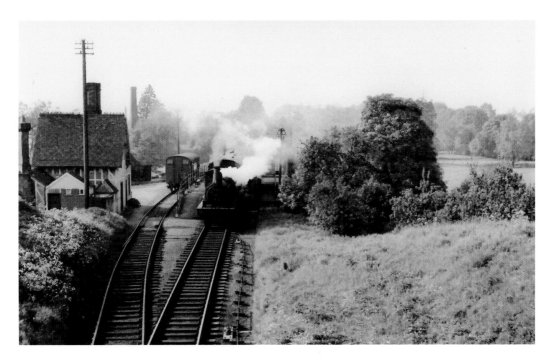

Head-on view of a Maldon-bound train at the small station in the early 1950s. The signal box was still standing but had been out of use since being closed in 1932 as an economy measure. It was eventually demolished, although some of the signal posts remained standing for many years albeit stripped of their semaphore arms. (David Lawrence/Photos from the Fifties)

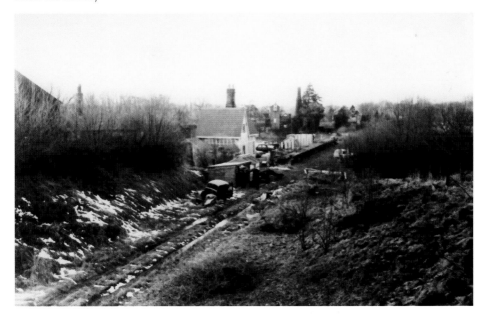

Less than two decades later this wintry scene shows the railway has gone, although in this view, taken in 1970, it looks like a dumping ground for old cars. The track had been lifted the year before. (Stations UK)

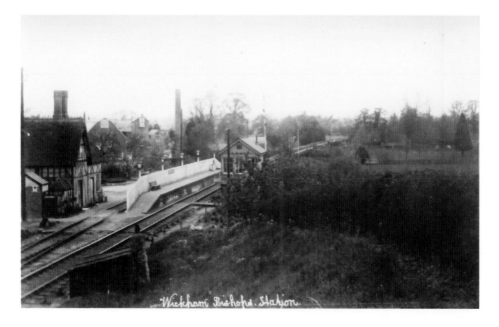

An early Great Eastern view of the station, building and signal box. The platform fencing at this time was wooden, and painted white. Note the original tall lower quadrant signal with its spectacle plate at a lower level, as at this time the station was fully signalled. (Lens of Sutton Collection)

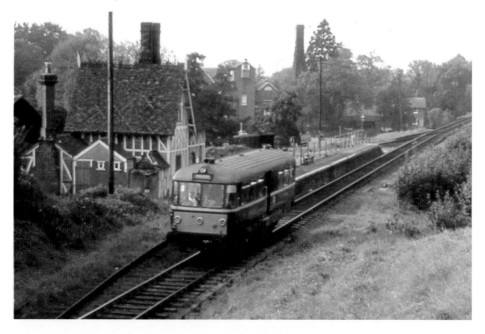

Many years later a similar view sees plenty of changes having taken place in the intervening years. This view, dated in the early 1960s, sees the diesel railbus departing towards Maldon. The wooden fencing has been replaced, and the signal box has been demolished, with the points at each end of the layout now controlled by ground frames, which were released by a key attached to the train staff. (Brian Pask)

Langford and Ulting

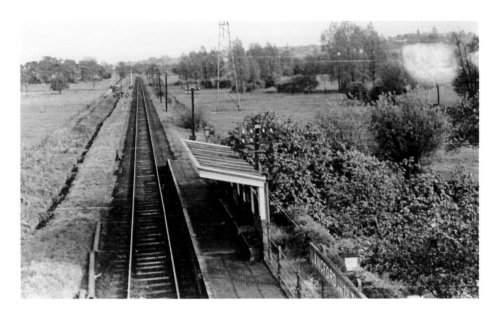

A view, taken from the road overbridge, of the simple station looking south towards Maldon. A small canopy completed the facilities. In the distance can be seen Maldon's distant signal. There was only 1 mile between here and Maldon East station. This view was taken in 1952. (Stations UK)

The road bridge has been filled in and, with the track removed, the former railway line seems to be in use as a public footpath. The platform and fencing remain hidden in undergrowth. (James Messer)

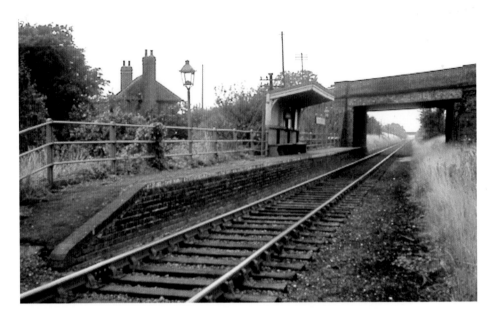

Early colour view taken from the trackside of the simple station provided at this location. This view is looking north through the road overbridge. Illumination was provided by three oil lamps, and a wooden seat ran the length of the shelter. (Brian Pask)

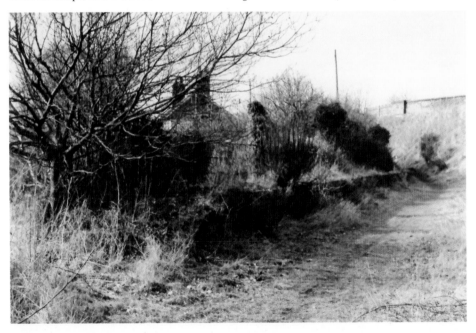

Twenty-one years after the last passenger train called here, this view, taken in 1985, is taken from a similar position as the previous one. The edge of the platform can be clearly seen, as can the bridge parapet, the underneath having been filled with soil and rubble. (Paul Lemon)

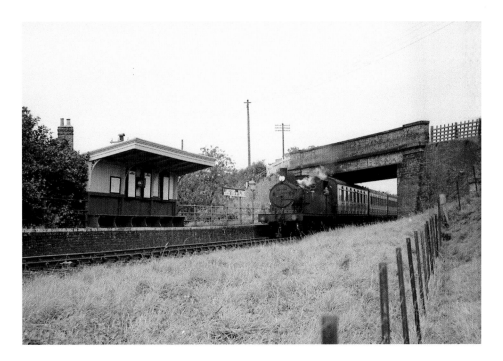

Steam-hauled service en route to Maldon enters the station in the mid-1950s. The advertising posters had been replaced with standard BR type when compared to the view on page 90. The steam-hauled passenger service was replaced with DMUs in 1956, and later railbuses in 1958. The adjacent house was used by the railway for the duration of its existence, and it is now a private house again. (Brian Pask)

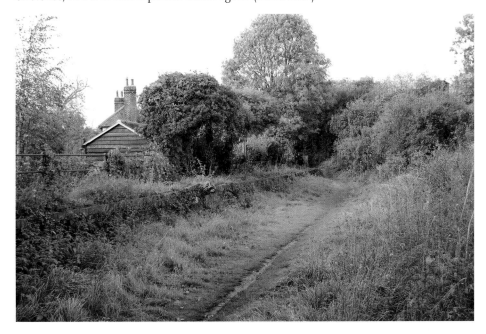

A visit in the autumn of 2012 clearly shows the remains of the old platform and fencing. The old bridge parapet is now completely hidden by vegetation. (James Messer)

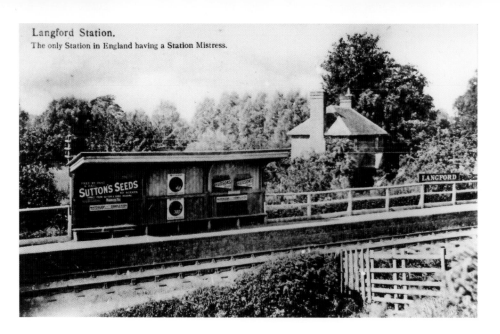

An early twentieth-century view from the 'Lens' archives, showing a close-up view of the waiting shelter and the platform with its original wooden railings. Two of the adverts are for 'Sutton Seeds' and 'Hudson's Soap'. The cottage used by the railway can be clearly seen in the background. (Lens of Sutton Collection)

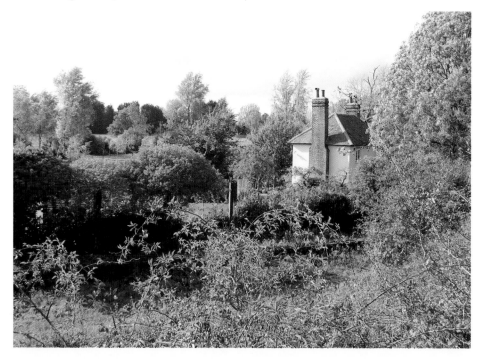

Elevated view taken from the road looking down onto the former station site in the autumn of 2012. The waiting shelter is long gone, but the house acts as a reference point. (James Messer)

Maldon East and Heybridge

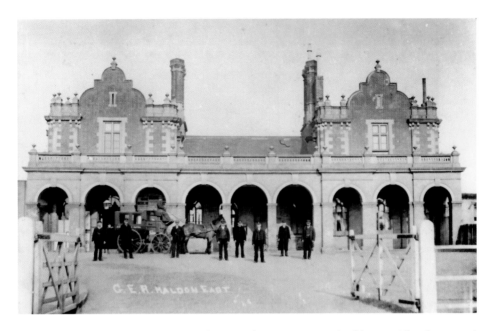

A lovely posed Great Eastern view, showing the ornate main buildings with a horse and carriage, together with the station staff posed outside for the cameraman. Although we know it was pre-1923, it would be nice to know the exact date. (Lens of Sutton Collection)

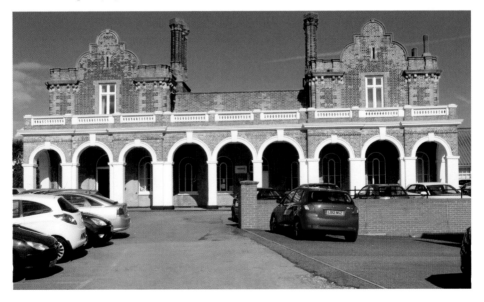

Today's colour view shows the station at its best, even if it is no longer a railway station. A new brick wall has replaced the old wooden fence, with the rest of the space given over to parked cars. (James Messer)

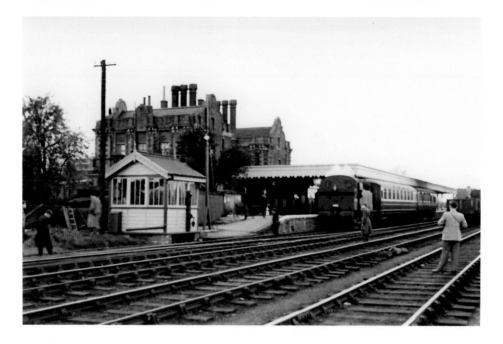

A Railway Enthusiasts Club special having just arrived at the station, this view was taken on 6 April 1957. Once the locomotive had run round it would take its train to Maldon West, which had not seen regular passenger trains since 1939, before returning once more to the east station for the trip back to Witham. From this view the size of the station buildings can really be appreciated. (Austin Attewell/Photos from the Fifties)

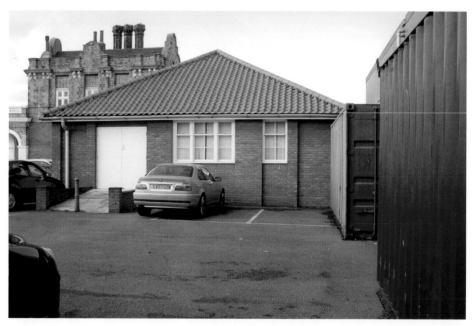

The old railway yard and surrounding area has been heavily redeveloped over the years, and trying to get a similar view is nearly impossible but, as this view shows, the old buildings still stand surrounded by the newer ones. (James Messer)

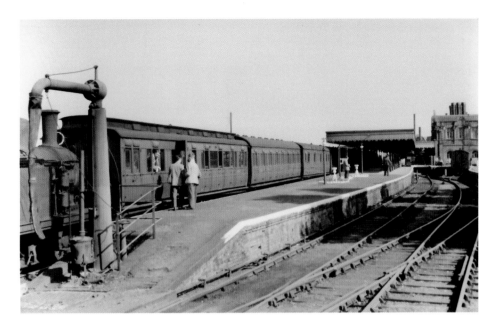

An August bank holiday weekend train stands at the main platform awaiting departure to Witham. The line on the right was the bay platform and loop. Note the brazier for keeping the water column from freezing up in the winter months. (Brian Connell/Photos from the Fifties)

The former platform canopy, now fully enclosed, makes a fine roof, still keeping the elements at bay some 160 or more years since it originally opened as a railway station. Motor cars now park on the former platform, and all the former railway land has been redeveloped with new industrial buildings. (James Messer)

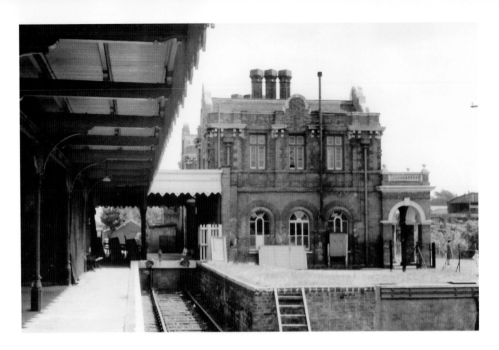

Close-up view of the bay platform and loading dock. To the right was a run-round line for locomotives to be released, with a short spur running back to the dock. The buildings have stood the test of time well, as by the time of this photograph they were into their 111th year of service. (A. E. Bennett/Transport Treasury)

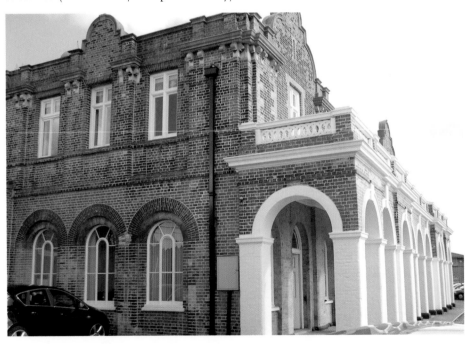

Close-up view of the front and side view of the former station buildings, which have seen various uses since closure of the line, including being a pub, restaurant and nightclub. Today they are used as offices. (James Messer)

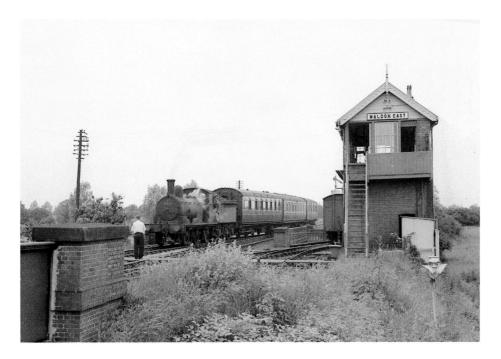

A lovely view of the railway, with the branch passenger train slowing to surrender the train staff and to enter the station, as seen in the mid-1950s before the arrival of the diesels. Little did anybody know that within ten years the railway at Maldon would be gone. (Brian Pask)

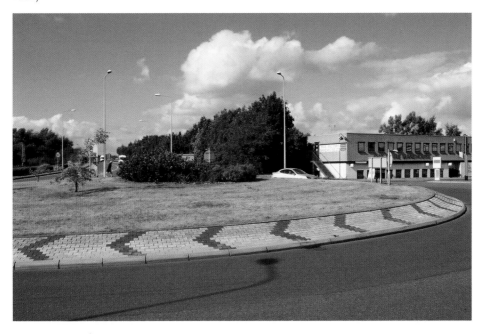

Today all signs of the railway have been swept away, together with the old signal box, which had stood derelict for a number of years after the box closed. It takes a lot of imagination to visualise trains running through the centre of the roundabout. (James Messer)

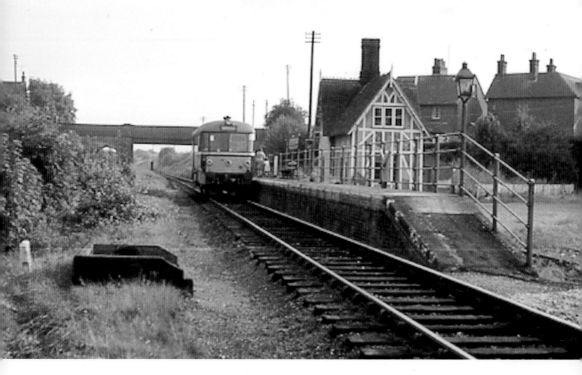

Early colour view of one of five Wagen- und Maschinenbau diesel railbuses, purchased by British Rail to be the saviour of the branch line, seen standing at Wickham Bishop's station awaiting departure with a branch service. By this time the goods yard seems devoid of traffic and the old signal box has been demolished. (Brian Pask)

Acknowledgements

Special thanks to James Messer for provision of the modern images. Once again, many thanks to Richard Casserley for allowing access to his photographic collection, and to Brian Barham, Michael Barnes, Brian Pask, Dickie Pearce, Lens of Sutton Collection, Paul Lemon, Wayne Claydon, The Railway Correspondence and Travel Society and the Historical Model Railway Society for help with the archive views. Thanks to all the other photographers and organisations that have provided views from their collections. Special thanks to Steve and Madeleine Scraggs for allowing access to their property at Easton Lodge.